THE GRIOTS OF OAKLAND
VOICES FROM THE AFRICAN AMERICAN ORAL HISTORY PROJECT

COMPILED AND EDITED BY
ANGELA ZUSMAN

THE GRIOTS OF OAKLAND

"Hope and pride ring through in the voices of the young men who have shared their stories with us through this beautiful book. *The Griots of Oakland* showcases the resiliency of our young African American men living in some of the most dangerous neighborhoods in the nation. The determination of these young men to succeed against all odds, even when the path is unclear and unsafe, is an act of faith, a demonstration of the power of hope. The Alameda County Faith Advisory Council is inspired by this collection and energized by the spirits that echo from the pages of this book."

Pastor Raymond Lankford, *Director*
Alameda County Faith Advisory Council

"*The Griots of Oakland* tells the story of Oakland's contemporary vibe — one of surprising hope and optimism from its unsung future leaders. Oral history and storytelling reaches back to the beginning of time, and in this case shows our capacity as humans to overcome temporary environments while always looking to the promise of opportunity that the future holds."

Alex Briscoe, *Director*
Alameda County Health Care Services Agency

"One of the most important obligations of a diverse democracy such as ours is that of listening to and hearing the diverse voices of all of the people in order to figure out what is right and the right thing to do. For far too long, the images and voices of African American men have been distorted and muted through the lenses and microphones of the mass media. Efforts such as *The Griots of Oakland* are critically important to the listening and hearing that form the foundation for understanding, concern, and care that lead to the actions necessary for us to improve the life outcomes of African American boys and men. The *Griots* displays the pain, the power and the promise of young African American men that should make us act."

Junious Williams, *Chief Executive Officer*
Urban Strategies Council

"It is important for us to tell our stories as we have lived them — without commentary from censoring and judging forces. It's extremely important for young people, especially young black men and women who are disproportionately incarcerated in the United States, to tell their stories so that others can learn from them, be inspired by them, and be uplifted by them. If we don't tell our stories then we stand the chance that someone else will."

Ericka Huggins,
Member of the Black Panther Party from 1967-1981
Director of the Black Panther Party's Oakland Community School
Professor of Sociology for the Peralta Community College District

"Finally! A vivid, complex and affirming portrayal of our African American young men and boys. *The Griots of Oakland* ruptures the distorted dark negative images of black young men and opens the mic for their own voices to shine! Any reader will be moved by their beauty and their brilliance!

Shawn Ginwright, Ph.D
Associate Professor of Education & Africana Studies
San Francisco State University

"Bravo and congratulations to Alameda County's Center for Healthy Schools and Communities, Story For All, the Oakland Unified School District Office of African American Male Achievement, and the African American Museum and Library at Oakland on the completion of this two-year endeavor. *The Griots of Oakland* is a great example of our community's ability to collaborate and share compelling insights regarding Oakland's African American youth that inspire hope and pride and address the critical issue of equity."

Rob Bonta
Assemblymember District 18

"It is not often that a project can so accurately capture the voices of a traditionally voiceless people with such creative authenticity. This project has provided us, the readers, with insight, reason and purpose to continue the fight for systematic equity while demanding communal change."

Jamaal Kizziee, MS, MFTI
School Based Behavioral Health Consultant
Center for Healthy Schools and Communities

"Our beautiful black boys cease to be invisible with this honest portrayal of their humanity. What a gift they've given to Oakland. This should be required reading for all educators, law enforcement and service providers."

Hon. Linda Handy, *Trustee,*
Area 3 Peralta Community Colleges

"As the Director of the Alameda County EMS Corps, a program that prepares young men for careers in Emergency Medical Services, I appreciate the knowledge, wisdom and creative expression that *The Griots of Oakland* represents. This project offers you insight into the thinking of today's generation of young black men striving to create a better life for themselves. It's a book that should be read by anyone interested in empowering the lives of young black men."

Michael Gibson, *Program Director*
EMS Corp.

"When people engage in thinking and feeling their way through the tangled web of social injustice, it becomes crystal clear that we need new narratives about those who consistently fall into the category of 'other.' Certainly, the false perceptions about black males run rampant throughout our society – this must change. We must connect the dots among the

kinds of stories that are available to us in this book, *The Griots of Oakland*. It must be circulated widely so that we can truly *see*, respect and admire the strength and courage that more accurately informs us of who our black brothers are. We can use these powerful stories as building blocks to reshape a cultural narrative that has been unjust and inhuman for far too long. Thank you for this project and let us welcome the continuation of the powerful griot tradition as part of our contemporary world that is in need of love, truth and justice."

Shakti Butler, Ph.D., *President and Founder*
World Trust Educational Services

"I am proud to be a part of Alameda County's feature on the story of African American young men and boys in Oakland. This is an inspiring project and it showcases the determination of our community's youth and a willfulness to succeed, even if that path is not apparent."

Nate Miley,
Alameda County Supervisor, Fourth District

"Alameda County is rich in the culture and traditions of the African American community, whose members have made important contributions to the Bay Area in the fields of education, arts, commerce and technology. Through the power of oral history and storytelling, *The Griots of Oakland* showcases the pride and talents of African American young men and boys who, despite all odds, are finding their voices and developing into leaders of the future. Congratulations to the young men featured in this inspiring book, to Alameda County's Health Care Services Agency and to the Office of African American Male Achievement for their leadership and dedication to the community."

Keith Carson,
Alameda County Supervisor, Fifth District

Story For All
Oakland, California
www.storyforall.org
info@storyforall.org

ISBN (softcover) 978-0-9887631-0-4
ISBN (hardcover) 978-0-9887631-1-1
ISBN (e-book) 978-0-9887631-2-8

Text and cover design by Cheryl Crawford
www.cherylcrawforddesign.com

Printed in the United States of America

The paper used in this publication meets the minimum requirements
of American National Standard for Information Sciences —
Permanence of Paper for Printed Library Materials, ANSI/NISO
Z39.48–1992.

Center for Healthy Schools and Communities
Linking Health and Education to Change Lives and Achieve Equity

The Center for Healthy Schools and Communities envisions a country where all youth graduate from high school healthy and ready for college and career. The Center is dedicated to fostering the academic success, health and well-being of youth by building universal access to high quality supports and opportunities in schools and neighborhoods. We value empowering families and youth, growing the capacity of communities to effect change and building strategic partnerships that link health and education institutions to achieve equity.

Story For All is a non-profit organization dedicated to educating, empowering and healing people and communities through the sharing of stories. **Learn more at *www.storyforall.org***

DEDICATION

The Griots of Oakland memorializes the commitment of the Center for Healthy Schools and Communities to equity in health, education, and economic opportunity for all. This book captures untold stories of inspiration and hope and in so doing shatters the stereotypes that plague and trap young African American men. Through the journey of their stories, the reader experiences the beauty and power of these young men and gains insight into the magnitude of their strength and contribution to ensuring the present and future health of our communities.

It is from this place of appreciation that we dedicate this book to the men who lent their voices to this project and to you the reader for your attention.

Tracey Schear, *Director*
Center for Healthy Schools and Communities

THE GRIOTS OF OAKLAND
VOICES FROM THE AFRICAN AMERICAN ORAL HISTORY PROJECT

*"When I read great literature, great drama, speeches or sermons,
I feel that the human mind has not achieved anything greater than the ability
to share feelings and thoughts through language."*

JAMES EARL JONES

*"How far you go in life depends on your being tender with the young,
compassionate with the aged, sympathetic with the striving, and
tolerant of the weak and strong. Because someday in your life
you will have been all of these."*

GEORGE WASHINGTON CARVER

FOREWORD

My name is Chris Chatmon and I am the Executive Director for African American Male Achievement in Oakland's Unified School District. As an educator and father of three African American male children in the Oakland Unified School District, my mission is to identify and increase educational, economic, social and leadership opportunities for African American males in Oakland, California and improve their life outcomes.

Our work began as a call to action. Four years ago, the former Superintendent, Tony Smith, together with Oakland Unified School District's Board of Education, embarked on a mission to create a full-service community school district. Steadfast in the belief that schools should be at the center of neighborhood and community life, they committed to provide a thoughtful continuum of services and support for the development of healthy children in partnership with residents and community organizations. This vision intends to help every family in Oakland thrive.

To make real progress on this universal goal, however, these education leaders had to confront a brutal fact; past initiatives and reforms had done little to transform the experiences, access, or educational attainment of African American male students. Accordingly, the superintendent and School Board took the unprecedented action of creating an Office of African American Male Achievement (AAMA). This demonstrated, to our city and the nation, our commitment to increase positive outcomes for the group historically underserved in our system — black boys.

The mission of AAMA is to stop the epidemic failure of African American male students in the Oakland Unified School District (OUSD) by creating systems, structures and a school culture that guarantees success for all AAM students in the OUSD. Through data we have identified entry points into our schools and systems to increase equity, improve cultural competency and implement practices that support African American male students. We believe all African American male students are extraordinary and deserve a school system

that meets their unique and dynamic needs. The work of our office was initialized and led by a team of volunteers and staff who started courageous conversations at all levels of the system. Their conversations identified both promising practices and obstacles to African American male achievement. These findings informed our office's strategy and actions.

"Umi said shine your light on the world," says artist Dante Terrell Smith, a.k.a. Mos Def. Yasiin Bey, in his rhyme about how his mother told him to shine his light said, "Don't be afraid to feel strong and powerful about your black maleness."

Being black and being male is a powerful position, so much so, that it can be intimidating to others. Those who feel intimidated have historically found ways to oppress African Americans. The external perceptions about African American male students in our society are overwhelmingly negative. The toxic images that local and national media portray of African American males affects their perceptions of themselves, their own abilities and their future.

It is our charge to surface voices and stories that have been buried so we can paint a panorama of stories that have been a mystery to most.

It is important for our youth to tell their stories and equally important for others to hear them. Part of our African American cultural lineage is storytelling in order to preserve our oral history. We have fought hard to maintain our communication style by sharing our stories with each other.

Oral history through songs and stories has kept us connected across generations. At AAMA we wanted to uncover these precious stories from young African American males across Oakland to invigorate a sense of pride and continue our oral tradition.

There is history and there is *our* story. We need to move from "Tel-lie-vision" to

"tell-my-vision." Most often, the rich history of Oakland does not come from the voices of African American males. One of our strategies within AAMA has been to lift up the voices and experiences of our African American male students to highlight the beauty and brilliance they exude and deserve. By increasing public recognition of the framing used to discuss the successes and challenges facing African American males, we hope to eliminate that framing and increase the positive images and experiences of African American males in the public sphere.

The civil rights issue of today is education and AAMA is making a difference. As a result of AAMA's efforts, there is a language and a platform for hosting conversations about different approaches to systemic change. The partnership with Story For All and Alameda County Health Care Services Center for Healthy Schools and Communities Agency has allowed us to bring our expertise together to capture the stories of our young men and expand our impact.

A special thanks to Angela Zusman, Story For All's Executive Director, for directing this project and getting the voices and stories of our Oakland youth documented in this book and a video exhibition in perpetuity.

Chris Chatmon, *Executive Director*
African American Male Achievement
Oakland Unified School District

INTRODUCTION
THE STORY OF THE AFRICAN AMERICAN ORAL HISTORY PROJECT

"Why do you care? Why do you care about our stories?"

Such was the prescient question asked of me by one of the young men we now know as *The Griots of Oakland*.

Why do stories matter? It was a question much like this one that started us off on this journey. It was 20011 and I was in a meeting with staff members from the Center for Healthy Schools and Communities, an arm of the Alameda County Health Care Services Agency. As part of their equity initiative, they were looking for innovative ways to support and shed light on the experiences of African American male youth throughout Alameda County. Knowing about the great work being done through Oakland Unified School District's Office of African American Male Achievement, they brought our organizations together and provided funding for the project.

I remember our first meeting. So much passion and care for these youth, so much enthusiasm about uplifting their voices. Yet it wasn't just about uplifting voices – we wanted to ensure these voices would be heard. After all, listening to stories is just as transformative as telling them. So, we aimed to create a team of story gatherers, young men who would not only collect stories but also become a living repository for their culture. **Griots.**

SEAN JOHNSON

CASEY BRICENO

JARVIS HENRY

NEQUWAN TAYLOR

ERIC NOBLES II

In West Africa, a griot is one of the most revered people in the community. Filled with confidence, treated with the utmost respect, the griot is the holder of the history and legacy of a family, community, or tribe. In Oakland, we need griots. We need youth who are confident in themselves, able to speak their truth, ask great questions, and listen to others. We need safe places where youth can speak truthfully about their lives, where they can feel understood and supported. We need to celebrate their achievements and their wisdom while learning how best to support them through their challenges. In the presence of a griot, we are humbled, curious, and open-minded. We are ready to learn.

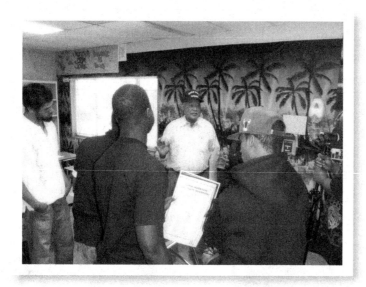

Learning Sessions,
KDOL TV Studios
April - September, 2012 Oakland, CA

Over the course of two years, we recruited and trained a group of young men in the arts of active listening, oral history and videography. Meeting every Friday afternoon, the youth conducted research, crafted questions and learned to setup, use and breakdown their recording equipment. Finally, they conducted oral history interviews with over 100 youth between the ages of 6 – 24.

Our goal was to speak with a diverse group of young men, from all corners of Oakland, so we set up our cameras at the bus stop at Eastmont Mall; a busy street corner in downtown Oakland; during a football game at Oakland Tech; and during after-school activities at

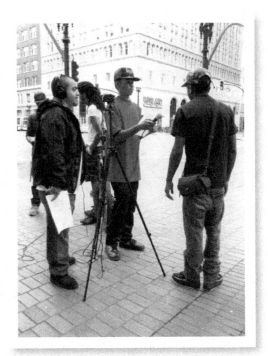

Interview Sessions,
Oakland Technical High School
October 19, 2012 Oakland, CA

Interview Sessions,
Downtown Oakland
November 2, 2012 Oakland, CA

Edna Brewer Middle School, Parker Elementary School, Martin Luther King, Jr. Elementary School and Youth Uprising.

We were ambitious. After all, we were aiming to change the discourse about how African American men are perceived. The media is saturated with imagery of African American men, but we wanted to learn what is true for these young men, to uncover and create a showcase for their wisdom, sincerity, hope, joy, and diversity. Sure enough, these young men blew us away. They spoke with generosity and fearlessness. They were polite, articulate and curious. While aware of the stereotypes and perceptions of African American men, they were able to transcend them.

What is perception? How do you perceive yourself? Other African Americans? As W.E.B. Du Bois stated:

> "It is a peculiar sensation, this double-consciousness, this sense of always looking at one's self through the eyes of others.... One ever feels his twoness, – an American, a Negro; two souls, two thoughts, two unreconciled strivings; two warring ideals in one dark body, whose dogged strength alone keeps it from being torn asunder."

This binary experience of self was one of the most interesting results of the project. It had an impact on everything, from the questions we asked to the way this book was organized. In many ways, throughout this project, assumptions were discarded as both of these visions were seen to be true. This book is about African American men in Oakland, but on a deeper level, it is about perception itself.

The young men in this book perceive with great clarity. Bluntly and with precision they expose the systemic factors that stack the deck against them. Check out the statistic on page 95. What happens to these beautiful young men as years in this system grind them down? Besides removing prejudice, there is much work to do in order to create lasting equity. We need many more people of all ages, races, colors and creeds, working together, dedicated to this goal.

This book in your hands was made to be read, pondered upon, used and re-used. For ease of use, some quotes have been omitted, others lightly edited. Word-for-word transcripts, available in the e-book version, tell a nuanced version of each young man's story, so we hope you'll check it out. 100% of the revenue from this book in all its versions will be used solely to perpetuate racial equity oral history programming in Alameda County for youth in the K-12 system.

The release of this book coincides with the opening of a major exhibition at the African American Museum and Library at Oakland. In this exhibition, community members can watch the interviews and experience the voices and images of the youth in a visceral way. Viewers will be able to add their impressions and answers to the interview questions, creating a living repository for these important stories. Videos of the oral history interviews will also be viewable online at *www.healthyschoolsandcommunities.org/griot*

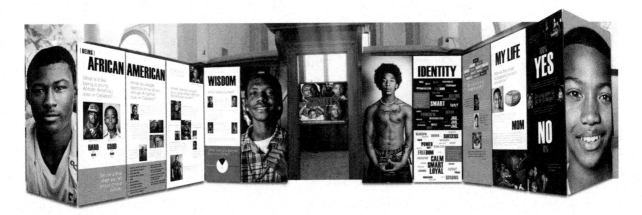

∧ shown above
Portion of *The Griots of Oakland* exhibit at the African American Museum and Library at Oakland

We hope this project will inspire other African American young men to share their experiences and for their communities to open their minds and truly listen to them. We hope other communities will engage in similar projects. We hope this book will become a dog-eared tool for educators, students, policy makers and people who are ready to move beyond prejudice. Most of all, we hope that the youth represented in this book will feel respected and perhaps even see themselves in a new way. This is already true for our interview team. As they've told us, some of the effects of this project include becoming more responsible; finding a career path; overcoming shyness and gaining social skills; having their minds opened to their community, their peers and even themselves. Such is the power of story.

If I live over here, and you over there, and we never talk – we might naturally come to believe that we are so different. There is no reason for me to go "over there" at all. Stories are bridges. When we are able to speak our truth, and hear each other, we find points of understanding, connection and respect. You are no longer so far away from me, so foreign. In fact, we are in many ways, the same. And now that we know it, we care.

This was my answer that day in the classroom: "Because I care. I don't know much about what your life is really like. There are a lot of assumptions about African American men. I want to know who *you* are. I care about you. I cared about you even before I ever met you. Your story is important, and I want it to be heard."

He smiled. He seemed to understand.

Let the stories flow.

Angela Zusman, *Project Director,*
African American Oral History Project
Founder and Executive Director, Story For All

The *African American Oral History Project* Team
Downtown Oakland
November 2, 2012

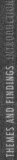

DON COOPER
DEWEY ACADEMY

CHAPTER ONE

IDENTITY

QUESTIONS AND ANSWERS

WHAT ARE THE FIRST THREE WORDS THAT COME TO MIND WHEN
YOU THINK ABOUT AFRICAN AMERICAN MEN IN OAKLAND?

WHAT ARE THE FIRST THREE WORDS THAT COME TO MIND
WHEN YOU THINK ABOUT YOURSELF?

IF YOU COULD CHANGE ONE THING ABOUT YOURSELF,
WHAT WOULD IT BE?

WHAT IS YOUR GREATEST STRENGTH?

WHO IS YOUR ROLE MODEL, AND WHY?

WHAT IS YOUR GREATEST ACHIEVEMENT?

DESCRIBE YOUR LIFE IN 10 YEARS.

WILD

GHETTO

PRIDE

HELP

DISAPPOINTED

GOOD

Challenged

MISUNDERSTOOD

FREEDOM

STRUGGLE

SHI

VIOLENCE

SHOOTING

KILLING

Independent

STEREOTYPICAL

What are the first three words that come to mind when you think about African American men in Oakland?

SMART

CRAZ

CRA

DRUGS

MONEY

RESPECTABLE

DEATH

POWERFUL

MARGINALIZED

NEGATIVITY

JAI

RECKLESS

JAI

SPORTS

FUN

JAI

Hardworking

HUSTLE

and more

JAI

BEAUTIFUL
SPECTACULAR
DRIVEN
SUCCESS
ATHLETIC
MOTIVATED
MANIPULATIVE
POWER
YOUTH
WISDOM
UNITY
DEDICATED

TALENTED
FREEDOM
humble

What are the first three words that come to mind when you think about yourself?

PROTECTIVE
CALM
SMART
LOYAL

OUTSPOKEN
INSANE

SPECTACULAR
FUNNY
happy

CURIOUS

awesome
HOPEFUL
STRONG
HARDWORKING

What are the first three words that come to mind when you think about African American men in Oakland?

STRONG

PRIDEFUL

REAL

MISUNDERSTOOD

CRAZY

STEREOTYPICAL

JAIL

JAIL

AND MORE JAIL

POWERFUL

DETERMINED

YOUTH

OUTREACH

MOTIVATION

SLEEP

SHIT

KILLING

INVENTIONS

STRUGGLE

MARGINALIZED

CHALLENGED

HARDWORKING

INDEPENDENT

INDIVIDUAL

DEATH

DRUGS

MONEY

DISAPPOINTED

DETERMINATION

HUSTLE

INTEGRITY

HELP

VIOLENCE

BASKETBALL

SPORTS

GUNS

NEGATIVITY

FUN

FREEDOM

JUSTICE

EQUALITY

AFRICA

UNITY

POWER

PRIDE

DRUGS

SHOOTING

TALENTED

UNDERESTIMATED

SMART

SUCCESS

POWER

STRUGGLE

WORKING HARD

BASKETBALL

DROPOUTS

" I don't think anybody really understands the extent of the pressure and the assumptions, misconceptions, that these African Americans go through."

— *Mario McGrew*

"Well, on the positive side, I think of where I'm at right now, Youth Uprising–Black-African American Uprising. You know, just looking out for each other. I see the brotherly love, 'Am I my brother's keeper.' You know, those kind quotes. But on the negative side it's more, like, it's corrupt. We don't know who we are no more. We disloyal to ourselves. We, I don't know, it's cutthroat, that's all I can really say. We cutthroat. It's like poverty. I guess it destroying us."

—*Kaulana Caldwell*

KAULANA CALDWELL
YOUTH UPRISING

ENDANGERED

DANGEROUS

BLACK PEOPLE

AFRICAN AMERICAN

STRONG

THAT THEY'RE GOOD

HELP

PEOPLE IN NEED

HAPPINESS

POSITIVE

POWERFUL

RESPECTABLE

RELIABLE

GOOD GRADES

ACHIEVING SOMETHING

TOUGH

THUGS

GUNS

GHETTO

FAMILY

WE JUST STICK TOGETHER

POTENTIAL

LOST

THE BLACK PANTHERS

STEREOTYPED

FEARED

ATHLETIC

STRONG

FUN

KIND

SMART

INTELLIGENT

RESPECTFUL

PEACE

LOVE

HONOR

TYPICAL

MOTIVATED

HYPHY

OUTTA CONTROL

BLACK

STRUGGLE

POWER

KILLING

SCHOOL

FAST LIFE

Motivated. I feel like we way more motivated, just because of the struggle most of us went through.

Kinda seem like they trying to be extinct. We losing too many of 'em. Need to be careful out here. Pretty much.

A little disappointed.
(*Q: Why do you say that?*)
Because, like, we all have so much potential. We're not living up to it, you know.

These niggas is wild, reckless and violent.

What are the first
three words that
come to mind
when you think
about yourself?

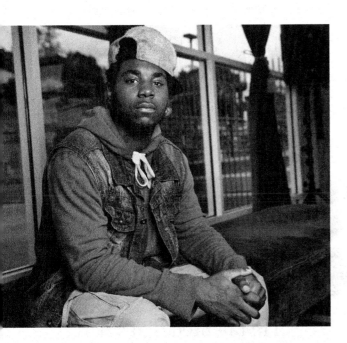

"Well, first and foremost–loyalty, y'know. My motto is, If it ain't loyal, it ain't nothing."

— *Aquan Markee*

STRONG	YOUNG
PRIDEFUL	FOCUSED
REAL	MANIPULATIVE
LOYAL	SELFISH
PROTECTIVE	CONCEITED
TALENTED	WISE
OUTSPOKEN	GOOD-LOOKING
DRIVEN	CAUTIOUS OF WHAT I DO
HUMBLE	CALM
TRUSTWORTHY	COOL
DEDICATED	COLLECT
CURIOUS	SELF-WILLED
HEALTHY	OUTGOING
INTELLIGENCE	HIGHLY INTELLIGENT
APPEARANCE	COURAGEOUS
HARDWORKING	INSANE
STRIVE	FUN
ACHIEVING	NICE
CREATIVE	ENERGETIC
BLACK	ATHLETIC
ARTIST	STUDENT
EXTRAORDINARY	PHYSICAL
SPECTACULAR	AWESOME
HOPEFUL	BEAUTIFUL
DETERMINED	FUNNY

TALENTED

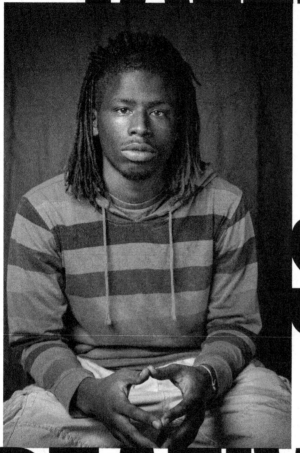

What are the first three words that come to mind when you think about yourself?

SMART

"I'm talented. I'm smart and creative."
— *Akeem Brown*

CREATIVE

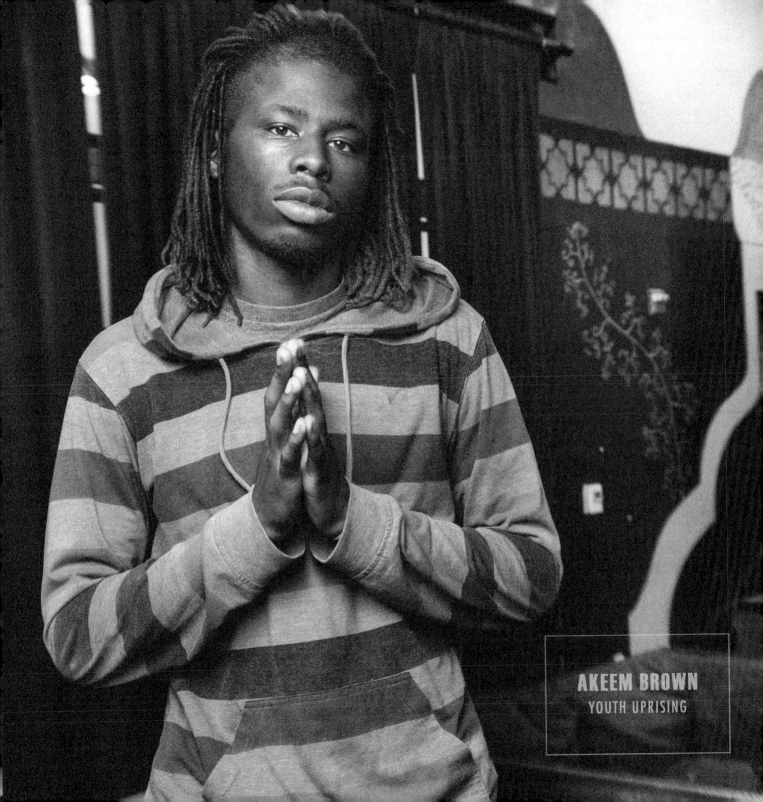

AKEEM BROWN
YOUTH UPRISING

ME, MYSELF, AND I... HAPPY BLACK

COOL HOPING RESPECTFUL

TALENTED ATHLETIC TALENTED

NERVOUS FUNNY CREATIVE

NOSY HANDSOME LOYALTY

BRAVE GOOD GRADES AMBITION

NFL PLAY MOTIVATED

EDUCATION SPORTS DETERMINED

FAMILY FUN HUMBLE

TALENTED SEXY SELF-OPINIONATED

SMART OPTIMISTIC INDEPENDENT

ATHLETIC POSITIVE GIFTED

AWESOME SMART HARDWORKER

HANDSOME WISE I KNOW HOW TO DO A **BACK**FLIP

NICE INTELLIGENT DO GOOD THINGS FOR MY BROTHERS

ACTIVE PRETTY AND MY SISTER

FUN FAST

I am very trustworthy. It's kinda ironic. I, Mario McGrew, am very trustworthy. It's hard to earn that trust. A lot of things that I've been through, a lot of friends who have, for a long time, been called family. None of them kept it real with me as somebody should have. The man I call my brother, I grew up with this man 17 of the 18 years of my life. You really see true colors in a lot of different situations. When I was young, I made a lot of decisions I shouldn't have made and that made me who I am today. I perform in something I shouldn't have done when I was younger.

Me and a group of friends decided to go into somebody's place and take something of theirs. I did this because, I was like, I felt comfortable in these situations. It was not the right thing to do but I wouldn't have gotten any consequences. It did not turn out to be the way, because the police were involved, although I wasn't in the picture.

I learned that friends and family definitely are not going to be there when you need them to be. So trust is hard to earn by me. On the other hand I am somebody that you can trust in, you can tell anything. I feel, like I can relate to a lot of things. I'm a very heartfelt person that everybody confides their trust in.

If you could change
one thing about
yourself, what
would it be?

APPEARANCE

SHORT

TALL

GROW MY BEARD FASTER

CHANGE MY TEETH

CLEAR UP MY SKIN AND

SHOW THE WORLD MY SMILE

"My hair. *(Q: Your hair, you don't like your hair?)* Nope, cause it's curly and nappy."

— *Damaria Sims*

PERSONALITY/BEHAVIOR

ANGRY

Not to get angry at people if it was like, a mistake… like if they do something really, really bad to you, you'd have to tell a teacher… or, something like that. *(Q: Okay, so you would change that about yourself?)* Yeah, because I don't really tell the teacher that much. *(Q: You don't? Why not?)* Because people call me snitches sometimes. *(Q: That doesn't mean you're a snitch, that just means you tell them 'cause it's tough.)* I know.

To be a leader and not a follower.

I would be more supportive to myself, so that I can be more supportive to others.

If you could change one thing about yourself, what would it be?

" Probably be my anger. Growing up I have been taught to deal with my problems by any means necessary. You take out whatever your parents give you and I grew up being an angry person. I was being totally and completely angry at anything that happened, at anything that would go on that I couldn't control – I get immediately angry. I snap on the person next to me. It's really me being angry, but at times I pent it up and I boiled inside and snapped on somebody I love. It wasn't healthy for me. I changed that now. I got back into boxing. I can change that now. It was a really bad habit."

— *Kendel Edwards*

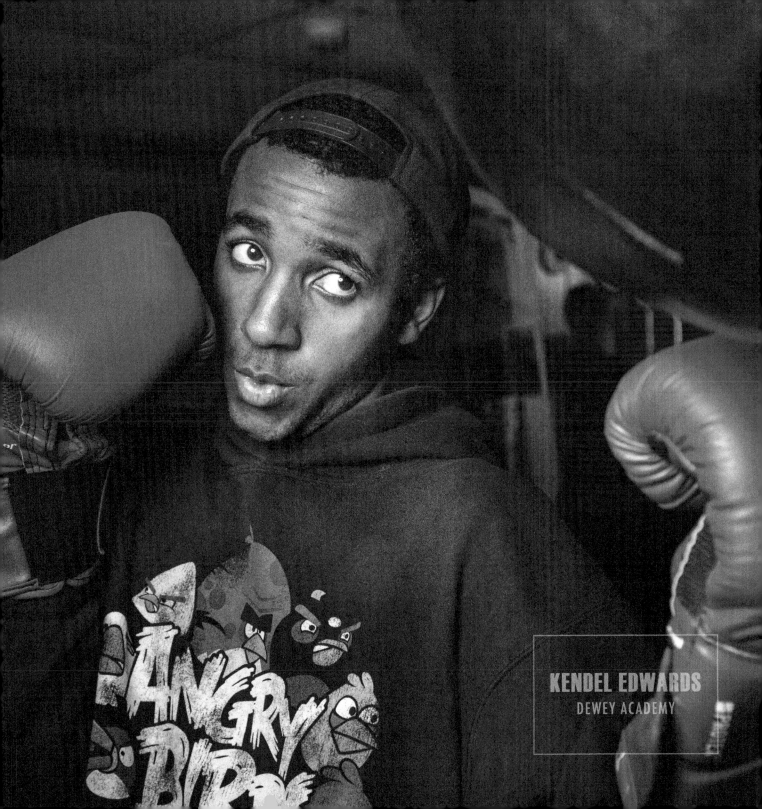

KENDEL EDWARDS

DEWEY ACADEMY

RUN AWAY FROM OPPORTUNITIES

I would change the fact that I run away from a lot of opportunities.
I feel like whenever I'm given an opportunity, I don't embrace it, and
it has held me back for so long. And I can honestly say that I am in
the process of that change, because this year is my senior year. I have
been a part of more programs than four of my high school years.
So that process is definitely in effect.

ACCEPTING/PROUD OF MYSELF

"I would just like to be more accepting
of myself and my situation. I'm like
constantly trying to better myself, and
you know, make myself better. And, I
think it's really important to just be okay
with where you're at, who you are, you
know? I mean not to say like, you know,
don't do good things and don't learn
things and better yourself, but don't,
feel, or try not to feel obsessed to be like,
oh I'm not good enough. That's what I
would change."

— *Benjamin Neomo Horgan*

I think it'd be how negative I can be toward myself sometimes. I'm the reason that I don't finish, or don't do some of the things that I can do. I put myself down. I'm my biggest – nobody is more tough on myself than me. I'm the one bringing myself down.

TRY HARDER/WORK HARDER

TALKING BACK

MOTIVATED/FOCUSED

BEING MEAN

BE MORE OPEN

STOP LYING

BE LESS OF A PLAYER

VIOLENT

LEARN TO SAY NO TO FRIENDS

I can be a little mean at times… in the morning. If I could just be happy in the morning when I wake up – that would be nice.

Be on myself more. Y'know, to stay more focused, to not drift off, honestly.

Stop being late to school. (Q: Why are you late?) I do not go to sleep at night, can't go to sleep at night. It's like the TV possess me or something, I don't know, just can't go to sleep.

"I actually wouldn't change nothing because I like being myself, and I wouldn't change nothing. I just like being me."
— *Kamran Stephens*

KAMRAN STEPHENS
EDNA BREWER
MIDDLE SCHOOL

SKILLS/ABILITIES/TALENTS

If I could change one thing about myself, then it would be to have superpowers. *(Q: What super powers would you have?)* I don't know, I would have a lot. *(Q: If you could have one?)* Super speed.

FASTER	MY LIFE
READ BETTER	NOTHING
THROW FARTHER	BEING ADDICTED TO MY VIDEO GAMES
I WISH I HAD A POOL TABLE	I WISH I KNEW THE THINGS I KNOW NOW A LITTLE BIT EARLIER

The violence that I used to do a long time ago. If I can change it, it'll be the good thing. *(Q: And what did you learn from your mistakes?)* I learned that doing things that you're not supposed to do. Because people that are around you can point the fingers at you and you become a victim.

I can't really answer that question 'cause what I'm not makes me what I am. I wouldn't change one thing. *(Q: And what are you?)* I'm an individual who sees the bigger picture in anything. What I got to fight for? I'm going to be hurt after. I see the bigger picture in everything.

What is your
greatest strength?

PERSONALITY/BEHAVIOR

My energy, my mindset. I'm calm. I don't get out of my wits. **I can keep calm in any situation.** And I'm a smart dude.

My personality. If you don't like it, you don't like it, but there's always somebody who's going to like it, whether you like it or not.

My greatest strength is **to work hard.**

Courage. I don't fear nothing. I'm not letting nothing stop me, can't nothing stop me. I'm going through every obstacle with smiles and happiness. Chill and relax, ain't nothing gonna hold me back.

My greatest strength is **my ability to know what I want.**

Just **having the power to make people laugh** — optimistic.

My patience. I think I'm a very patient person, it helps me get through a lot of situations where I feel like I don't know how to get past it and time is always of the essence.

I'm good at having fun.

My greatest strength is to **engage in things**, 'cause once I get engaged I feel like I'm in there and I feel like that's what I'm good at.

Personality (*Q: Why?*) Because my personality shows the fundamentals of myself. (*Q: How would you describe your personality?*) Kind of like the things that describe myself. Funny, awesome, fantastic.

I'm a big thinker – I think deeply about things. I'm not ignorant.

My determination to get stuff done and to make sure I have everything done on time, and to focus on school.

My greatest strength would be **to work hard.**

Family. They support me.

What is your
greatest strength?

CALM
COURAGEOUS
AND PATIENT

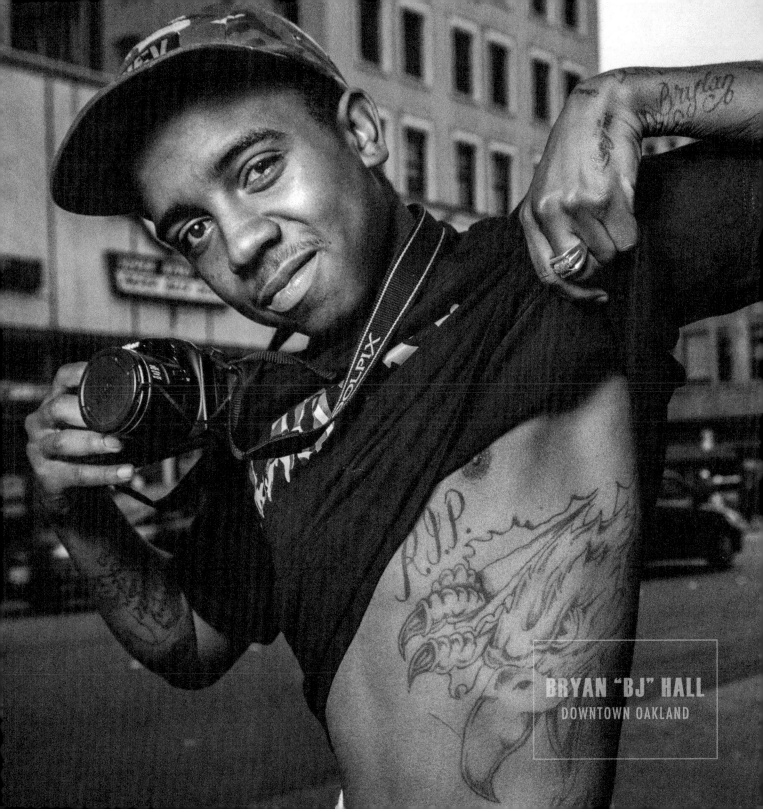

BRYAN "BJ" HALL
DOWNTOWN OAKLAND

Patience. (*Q: You have a lot of patience? Do do you remember a situation where your patience was tested and you passed?*) Actually it was a couple of weeks ago in class, and an argument had broke out, and I was involved in this argument, and my patience allowed me not to get up and fight him. Everybody was trying to tell me, get up and fight him, get up and fight him, and I was like, I'm not about to fight him – no point in it.

My greatest strength is my **muscles**. Eating good food like broccoli, because my mom, every time she cooks something, it has vegetables. And every time she says, if you don't eat that then you can't eat what's on that other, that sweet stuff. So I eat that on that plate before I eat this on this plate.

My mindset would be my greatest strength.

I won't let nobody tell me what I can't do. I kinda go against the grain. You tell me I can't do it and it makes me feel like, oh well since you said I can't do it, I'm gonna do it. And even if I'm wrong, a lotta' the time, I'll, still, try to do it. So, that's my greatest strength.

My greatest strength is **knowing that I'm black.** (*Q: And how is that a strength?*) 'Cause, I know for a fact that if I graduate high school, blacks are most likely to be accepted at any black university.

SKILLS/ABILITIES/TALENTS

Probably **my creativity, my imagination.** (*Q: Are you an artist, dancer?*) Yeah, I paint, I draw, I like to sculpt, yeah, that's my stuff.

My art. Visual artist.

My greatest strength is **knowing how to talk to people** and knowing how to communicate, and not just on a "brother-to-brother" basis.

"I think my greatest strength is that I kept a level head despite everything that was going around me. I think, part of that too is that I was fortunate to have good people around me, such as my father, my coaches, my family and the people around my school as well."

— *Erick Jackson*

ERICK JACKSON
OAKLAND TECHNICAL
HIGH SCHOOL

LEARNING

BASKETBALL

KICKBALL

MATH

I WORK WELL WITH PEOPLE

EATING RIGHT

BACKFLIPS

SCIENCE

LIFTING WEIGHTS

MY SPEED

BASEBALL

I'M SMART AND I'M GOOD AT READING

"Knowledge."

— *Yeheshua Salam*

My greatest strength is when I run laps. *(Q: How many laps do you do?)* Sometimes he makes us do six, but last year we did twelve. Mr. Roberto. And it's fun. *(Q: You like running. How do you feel when you run?)* Excited. *(Q: Excited? Why?)* I feel excited because all the wind is flowing through my body and stuff when I run.

My greatest strengths are **sports, math and English.**

My greatest strength has to be science. I like studying molecules and animals and seeing more about the earth, and geology and biology.

Science. *(Q: Science? What kinda science?)* Life science.

Football

Football, my brain, and my brain.

I can play football very good.

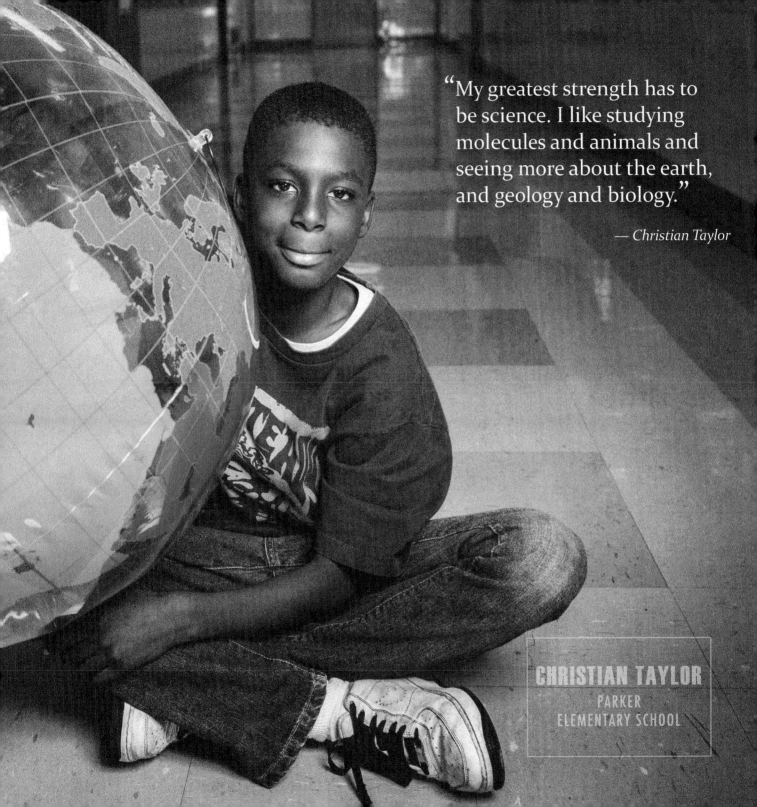

"My greatest strength has to be science. I like studying molecules and animals and seeing more about the earth, and geology and biology."

— *Christian Taylor*

CHRISTIAN TAYLOR
PARKER
ELEMENTARY SCHOOL

Who is your role
model and why?

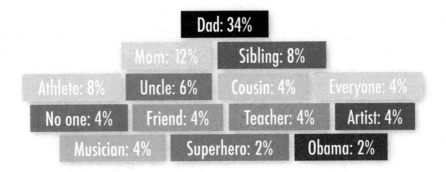

DAD

My dad, really, 'cause he's just a good man and he does – he takes care of his business and me... makes sure I'm right.

My role model is my father because he created the African American Male Achievement Program. And he is – he's just someone to look up to.

My role model would be my father. I look up to him all the time. He's the one that teaches me how to be a man.

My role model is my dad because when I grow up I want to be exactly like him. Be... well, successful, I mean well successful, wealthy, and just do what he gotta do.

I think my dad is, because he didn't go to college, except he's a really strong person. He'll get everything done for me and my brothers.

My sister and my dad. Because my sister, she did good in school and then she finished. Then she went to college. Then she – and now she has a job. *(Q: Do you know what college she went to?)* No. And then my dad because, because, he made it through. Like, because he plays football and he teaches. He played football when he was younger and he teaches me how to play football.

My dad is my role model because he pays attention to me a lot, and he pays attention to his kids, and he wants us to go to college and be successful and he wants us to put him in a safer place when he gets older.

My dad because he helps us with our homework a lot.

My dad because he's always been there, and he was a good father, you know.

My pops, because he done been through my footstep – I mean he done already did it all before.

My role model would be my father, because despite all of the negitivity – despite all that he was, all the challenges that we faced, he always put me and my sister, my younger sister, all of our sisters – he put us before himself and he always – he always took care of us, despite whatever happened. He just, he always stayed strong.

My role model is my dad, because maybe I can have dreams like him and keep my hopes up.

My dad because he always takes care of me and even my mom. My dad tell me, anything that's going on, just tell me, don't ever, ever just keep it inside of you. Because if you keep it inside you, then something's wrong. Or tell me if your mom and your baby sister don't have any more food in your refrigerator, that we almost eat it all. Just tell me that, so I will buy you some more food. He always gave me money to go to the store. He always came to my birthday party, when I had one. He always come to me and my friend's sleepover so we can go somewhere and have fun.

My father, because he keeps me going. He teaches me how to be a man and the steps that I should take.

My dad and my brother because they're always telling me to do my best.

MOM

Mom, mom. Mom and this artist, Hayao Miyazaki – incredible storyteller. Anyway, yeah, mom.

I have to say it's my mom.

I'd say my mom because she raised me by herself, without my dad and all that.

My role model is my mom, my grandma, because they're always helping me and showing me which way to go, instead of being a bad person. They're always showing me what to do and that's really good.

My mother, because she is the closest person to me right now. I admire her because my mother takes care of me and feeds me.

PARENTS

Definitely my parents because they're strong, hardworking and independent. They've always supported me through everything and I really value that.

SIBLING

My brother. *(Q: Why your brother?)* 'Cause sometimes he do good and sometimes he do bad.

My big brother, it's because he don't take no for an answer, he keeps going, like, succeeding at what he tries to do.

ATHLETES

I will probably say that my role model is Michael Jordan. Dude followed his dream. He did what he wanted to do with his life and didn't let anybody stop him from doing what he wanted to do in his life. And that is what I want to do. And I don't want nobody in my ear constantly telling me that's not smart. "Be smart about your decision." Now I don't want to hear that.

My role model? My role model has to be Chris Paul, man. He conducts hisself so well, on the court and off the court, you know what I'm saying?

Monta Ellis. *(Q: Monta Ellis is my boy! But why? He's inspired you to be a basketball player?)* Yeah. Well, yeah, and my favorite number is eight because of him, so, well now his number is eleven, but it's still always eight to me.

Nick McFadden.

"My role model is my brother. Because he goes to school every day. And he has changed his posture and behavior a lot and he has gone since he was eight and has just grown a lot."

— *Yeheshua Salam*

UNCLE

My Uncle Yancy. He taught me everything I know, damn near, about cars, you know what I'm saying? That's why I'm going to college right now, to be a mechanic, you feel me? So, I'd have to say my uncle.

My uncle. *(Q: Your uncle?)* Yeah. *(Q: Why?)* 'Cause he's not like all the other people you see out here on the streets and stuff.

That'd have to be my uncle. And because, I don't know, I just could tell my uncle anything and everything. He wouldn't get mad.

COUSIN

My role model, to be exact, is my big cousin. He's only one year older than me. His name is Anayis. He's my role model because he inspires me to get out and get active and he shows me how to play basketball, football – he just shows me a lot of great things. That I can just get out and get active and don't care about what anybody thinks.

My cousin, because he went to college and got a degree.

EVERYONE

My role model would be... I wanna say everyone, because I feel they motivate me either from what they don't have or do have. If you don't have anything, I feel like I would want to help. And that gives me the motivation to be able to achieve what I need.

I have multiple role models. Everyone who's in my life, and brings positivity into my life, is a role model. I've grown and become the man that I am because of the people that surround me, my friends, even people the same age. I feel like I got a gift, or I see what I should take from the individuals that are around. If it's something that I see, like okay, I need to be that, I mimic it, and I'll copy it, and I've taken a little bit from everybody that I've been around. And that's how I grew up to be how I am. So I'd say everybody who's around me and that's positive is a role model.

NO ONE

Don't have a role model.

My role model is, uh, I don't have a role model.

My role model would be... I don't have one.

FRIEND OR PEER

My role model... my role model – he's not even here no more. His name was Raymond Lamont Justice. He got gunned down in 2010 walking home from his school, Oakland High. He was just an overall stand-up guy. He was 17 when he passed and he was just – he was just the coolest. Everybody loved him. Everybody wanted to be around him. He rapped. He was just the coolest.

My role model, whew, that's a hard one. My role model is every kid that's trying to make something out of themselves.

TEACHERS

My role models are my teachers because they're driven and they really excel in what they do.

Brother Jahi. *(Q: Brother Jahi? Why?)* Because he always makes the right decision and he always knows what he's doing before it happens.

ARTISTS

I guess one of my role models is Masashi Kishimoto and Michael Dante DiMartino. They are writers of two animes that I really like, that I'm basing a lot of my stories I'm going to write – and animes and stuff in the future.

MUSICIANS

I would wanna say Bob Marley, he is one of 'em. And it's like, because he is one of the people that – like, his music helped me relax more.

Wiz Khalifa... yes, I would call him as a role model to me. *(Q: Why?)* Why? Because, it's not always about what he talks about, y'know he likes – like he said, he might do a lot of weed, but weed is not his first priority. Y'know what I'm saying? It's music. So, that tells me right there his – even though he raps about it a lot, that's not his number one priority. His family, y'know, he's about to become a dad, so a true man to his words. His loyalty is to everything he do. Yeah.

SUPERHERO

My role model is Dash. *(Q: Dash? From which show?)* It is a movie, *The Incredibles*. *(Q: And why is that your role model?)* Because, like you asked me a few minutes ago, super speed and he runs really fast and he is a superhero.

OBAMA

I would have to say Obama, 'cause he's the president. First black president.

"My role model is my dad, because he teaches me how to be a man and never to look down on myself and never to look down on whoever around me and what I'm doing."

— *Cleo Senegal*

CLEO SENEGAL
DOWNTOWN OAKLAND

What is your
greatest
achievement?

EDUCATION

My greatest achievement is being an African American Male Achievement award recipient my first year in Dewey. So that is one of my better achievements.

My greatest achievement would be graduating high school in a couple of weeks. I'm too stoked. I'm over excited.

My greatest achievement? Well, this year is my greatest achievement. Because last year, when I was in school, I was doing bad. But this year, when it comes around, when I'm being a senior, it's like everything comes together and I do what I got to do. Shit, I'm positive!

My greatest achievement is still being in school. That's my greatest achievement.

Getting a 3.97 on my report card.

My greatest achievement was last year when I got five A's and one B. Because I really wanted that 4.0, and that was closest I ever had to a 4.0.

My greatest achievement is to finish my last school year, and to go through school. And sometimes it can be hard.

My greatest achievement is graduating from elementary school.

Having good grades.

Probably getting a 4.0 in the 6th grade.

My greatest achievement? It was getting Student of the Month last year at Edna Brewer, 'cause all the hard work actually paid off. And I knew that I made it to the 7th grade.

I think getting 4.0's is my greatest achievement.

My cursive writing.

Getting the African American Male thing – when you get an A – or if you get a 3.0 or higher, you get a lil' certificate.

As of right now, I know I'm gonna get into college. I mean, that's it... but, I can't really think of nothing right now, like – I still feel like I'll have more to do.

My greatest achievement is to get all A's on my report card. *(Q: What are your grades looking like now?)* They are looking good. I have B's *(Q: What do you need in order to get them to A's)* What I need in order to get A's is to be good in the classroom and don't be disrespectful.

My greatest achievement is when I got an A$^+$ in science.

My greatest achievement is when I was in second grade. I had gotten an A in math.

My greatest achievement is me pulling my grades up in school. *(Q: So you used to have low grades?)* Yes. *(Q: What made you want to get better grades?)* My mom and my brother encouraging me to do better, and me moving here to a better school.

Making it through high school 'cause a lotta my friends didn't graduate high school. So, that's what mine is. *(Q: Were there any challenges, obstacles, you faced throughout high school?)* Uh, not really. No. *(Q: So it was a smooth...)* It wasn't smooth. School was okay. Had my little troubles inside the school and outside the school, but I just managed to keep on working and just keep on pushing and trying. *(Q: And how did you manage that?)* Just stay in the teacher's classroom, just every day, just be there on time every day, hand 'em every paper back that they hand to you.

ARTS

Just my art. My art is an achievement. I see my art and I love it.

SPORTS

Being good in basketball.

My greatest achievement is to be able to play basketball with my favorite team, the One

Nation Team, and so far we're making good progress and soon our big game's coming up.

Oh yeah, I almost know how to do a back-flip with no hands.

Football.

Playing in tournaments in L.A. and Reno, Las Vegas. Basketball.

Improving in football and basketball. And my cursive writing.

MVP's, trophies, championships, baseball, football, "Defensive Player of the Year."

BEING ALIVE

My greatest achievement would be where I am now. Me being alive.

My greatest achievement man, is, shit, waking up every day and staying alive. Not a lot of people can say they does this every day.

As of now, still being alive. *(Q: And why do you say that?)* Well… just a lot been going on lately… it's been a lot.

FAMILY

The best not yet to come. *(Q: And why is that?)* Because I feel like you can always do greater. My long term goal is to never leave my family with nothing. So in order for my last achievement to be succeeded, I would have to be passed on from this life with my family having everything I didn't. That's my greatest achievement.

My son and my daughter.

My greatest achievement is becoming independent and not relying on people so much.

My greatest achievements? Being on the news and being looked up to as a successful young black man.

PERFORMING

I said the Martin Luther King speech in 9th grade, the "I Have a Dream" speech. I read the whole thing in front of the Black Student Union, in 9th grade – coming in as a 9th grader. They selected me outta nowhere. They just came to me one day and said, "BJ, I want you to read a speech in front of a bunch of people." It was NAACP people. City council people were there. I'm talking about, I got up in there and I just fluently read it. One time – in 9th grade – it was so many complicated words up in there, but I just knocked it out.

My greatest achievement? I think my greatest achievement is when I had to show out somewhere for basketball and I did. It was on a big stage – high stage, and I did. I'll never forget it. It was at the Blue Williams and it's a EYBO thing, if anybody ends up noticing what I'm talking about. And I showed up and showed out and that's when I got all my recruits and everything and I felt good.

NONE

I'm not sure.

I don't think I have reached any great achievements yet.

I couldn't say that right now.

MISC

Having a surprise party.

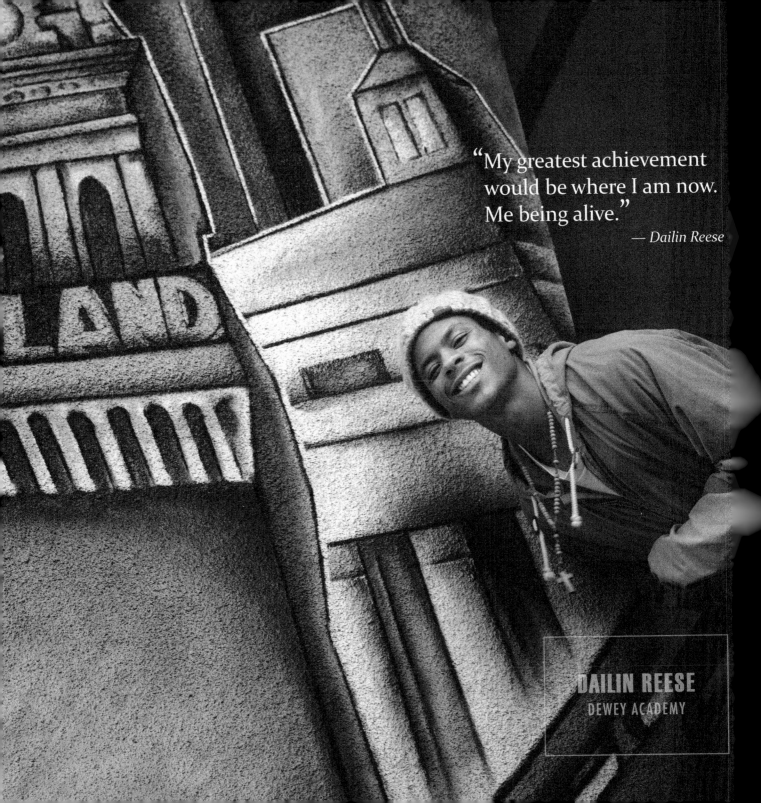

"My greatest achievement would be where I am now. Me being alive."

— *Dailin Reese*

DAILIN REESE
DEWEY ACADEMY

Describe your life
in 10 years.

HELPING PEOPLE/GIVING BACK TO MY COMMUNITY (9%)

Ten years? Man, Aston Martin with the top cut off, you know what I mean? With a little lightskinned peanut butter thing coming out my seat. Naw, 10 years, I'm giving back, I don't care if I, you feel me, if I make it. I'm gonna make it and in 10 years I'm giving back to the society. I'm not just talking about I got money to blow, I got money to spend on some books for the kids.

ATHLETE (9%)

PSYCHOLOGIST (7%)

SUCCESSFUL (7%)

Ten years, huh? I would have everything. Every single thing in my mind that I want, I will have... 10 years from today.

I HAVE A FAMILY (5%)

MUSIC INDUSTRY (5%)

"In 10 years I hope to become a music producer. I hope to have started a new family. I hope to have worked around the world. The world revolves around music. Like we didn't have music, imagine how boring this world would be. Imagine the stuff we be doing, just without music. So I feel music helps the world in the long run."

— *Aaron Johnson*

ARTIST (5%)

IN COLLEGE (5%)

In 10 years I'll be 20 and I'll be in college probably... and I'll play for the college football team, whichever college I go to. And I really don't care if they lose every game. All I know is, that I'm gonna try to put them in a safe place and make us win.

FAMOUS (3.5%)

I'm just gonna be BJ, everybody gonna wanna be around me, everybody gonna know me, you know? Be one of those, "that's him!" One of those people, like if I come around, they gonna be like, "that's him."

In 10 years I'll be 22 years old... well, 21, and then I will be – I would wanna be famous for – I'm gonna try to help Oakland and be famous for cleaning up Oakland and helping the streets and dedicating a lotta stuff to Africa and kids.

I AM SAFE (3.5%)	**ACTOR (2%)**	**ACCOUNTANT (2%)**
NICE HOUSE, NICE CAR (3.5%)	**KARATE MAN (2%)**	**MARKETING (2%)**
I HAVE A JOB (3.5%)	**DOCTOR (2%)**	**THEOLOGIST (2%)**
BUSINESSMAN (3.5%)	**MEDICAL ASSISTANT (2%)**	**DON'T KNOW (2%)**
COLLEGE GRADUATE (2%)	**RN (2%)**	**NOT WORRYING ABOUT MONEY (2%)**
I AM RICH (2%)	**PROFILER (2%)**	
PHOTOGRAPHER (2%)	**CRIMINAL JUSTICE (2%)**	

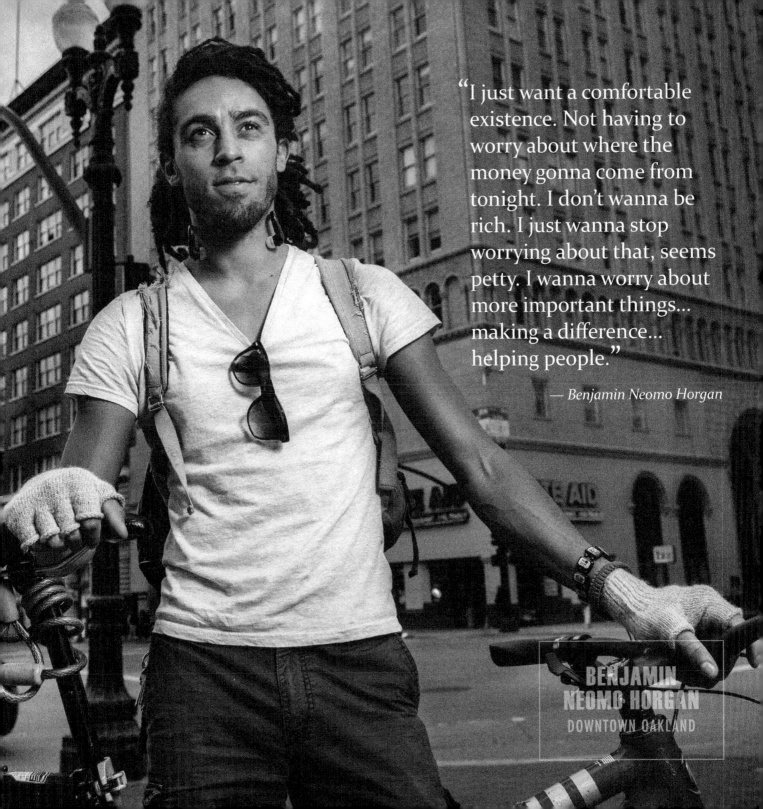

"I just want a comfortable existence. Not having to worry about where the money gonna come from tonight. I don't wanna be rich. I just wanna stop worrying about that, seems petty. I wanna worry about more important things... making a difference... helping people."

— *Benjamin Neomo Horgan*

BENJAMIN NEOMO HORGAN
DOWNTOWN OAKLAND

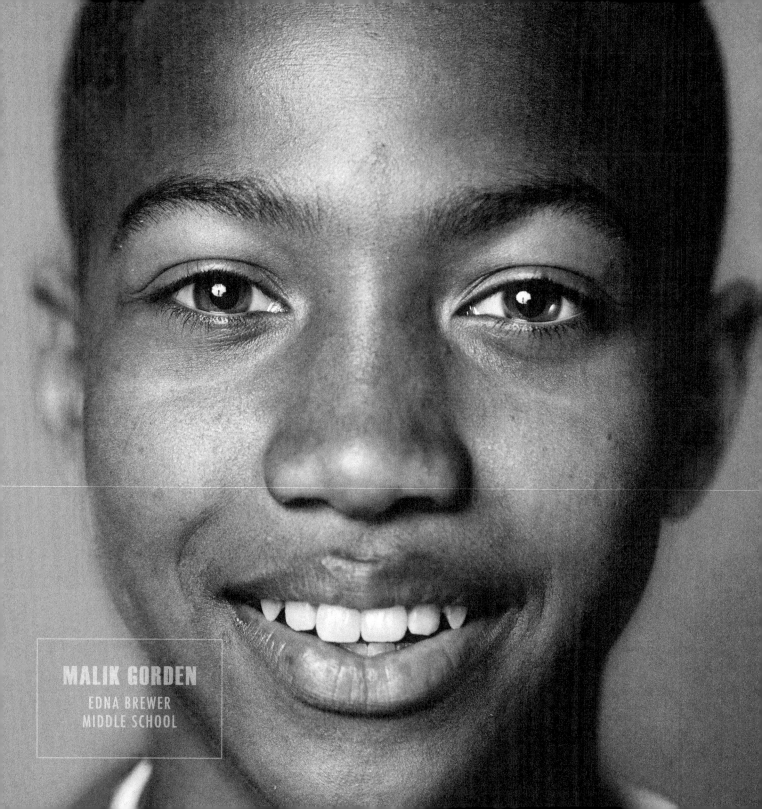

MALIK GORDEN
EDNA BREWER
MIDDLE SCHOOL

CHAPTER TWO

MY LIFE

QUESTIONS AND ANSWERS

WHAT DID YOU EAT FOR BREAKFAST TODAY?

WHAT IS YOUR FAVORITE CHILDHOOD MEMORY?

WHAT IS THE SCARIEST THING THAT EVER HAPPENED TO YOU?

WHO IS THE MOST SUCCESSFUL PERSON YOU KNOW?

WHAT MAKES THEM SUCCESSFUL?

IF YOU COULD CHANGE ONE THING ABOUT YOUR SCHOOL,
WHAT WOULD IT BE?

DO YOU PLAN ON GOING TO COLLEGE?

What did you eat for
breakfast today?

CEREAL – 32.6%
 REESE'S PUFFS
 APPLE JACKS
 CINNAMON TOAST CRUNCH
 FRUIT LOOPS
 FROSTED FLAKES

NOTHING – 19.6%

PANCAKES – 4%

A SCONE – 4%

WAFFLES – 4%

EGGS AND BACON – 4%

ORANGE JUICE – 4%

MUFFIN – 2%

GREEK YOGURT WITH GRANOLA – 2%

YOGURT AND BEEF JERKY – 2%

PANCAKES, BACON AND KOOL-AID ON THE SIDE – 2%

OATMEAL – 2%

BAGEL – 2%

CUP-A-NOODLES – 2%

TOAST – 2%

CHICKEN – 2%

SAUSAGE, EGGS AND PANCAKES – 2%

EGGS – 2%

What is your favorite
childhood memory?

> "Playing sports, running around the neighborhood, meeting new people."
>
> — *Anthony J. Johnson*

SPORTS (23%)

Probably being in my backyard, playing basketball, shooting free throws.

If I was to choose one, it'd be the first time I made a half-court shot in basketball.

When I first got on the baseball team.

It wasn't really childhood - it was last year. I hit my first home run in baseball.

When I played basketball for the first time at Garfield Elementary School.

My favorite childhood memory has to be – that's a hard one, I have so many good ones. Playing basketball at... what is it called? My bad, man, I forget the park... it's in North Oakland... *(Q: Mosswood Park?)* Yeah, Mosswood. Growing up, playing at Mosswood.

Hitting my first game winning shot.

When I was first playing basketball.

When I had a basketball game. I was playing with middle school students and I scored a shot.

Playing football. *(Q: Football, you was playing football in your younger years? What position do you play?)* Quarterback.

When I first started doing **back**flips.

FAMILY (21%)

Spending time with my family *(Q: What did you guys do that was so memorable?)* I remember all the times with my family. My favorite part of my childhood memory is just spending time with family... all together. Like going on trips, airplane rides, drives, vacations... lots of different stuff.

We just enjoyed our day. It was the last day I ever got to see her, so you know, it's one of those moments you probably never forget. *(Q: Did something happen to your mom?)* Umm... yeah, unfortunately. She passed away December 26th, 2006 at approximately 3:00 AM.

Being at my great-grandma's house on 39th.

> "My favorite childhood memory was when I went to the beach with my mom and my cousin."

I would have to go all the way back. Any memory I still have of my grandmother. 'Cause my grandmother passed away when I was about eight, so any memory that I still have being with her. Being around her, talking with her, any of her words that still pop up in my head. Any of that is my favorite childhood of memory.

It's actually, probably just hanging out with my mom and dad. You know, just spending time with them on the weekends.

All the times I actually sat and played with my cousin.

My favorite memory was when I turned four because that's when I first met my Grandma.

One year I was staying in the East on 96th and Sunnyside, it was just one year that me, my mom, my dad and my sister were able to stay in one house, and it was just like – it was just a solid year.

It would have to be when my brother was sticking up for me.

When I was with my mom. *(Q: And what were you guys doing?)* We were just out in the hotel enjoying ourselves.

My favorite childhood memory was when my dad bought me my phone.

PLAYING/TOYS (17%)

Probably my first Hot Wheels set. My dad brought it for me for Christmas

Climbing trees.

Lego Star Wars at age six.

My daycare.

Toys. Playing with toys at daycare.

When I was at my granny's house and we was in the backyard, and we was playing, throwing rocks and see who can get the closest to the fence, yeah, and we was trying to hit it. *(Q: And it was you and who?)* Me and my cousins... and it was one of my big cousins named Devario.

Playing in the jumper.

Well, we didn't really have a lot of money, so I used to like the little stuff we did. Like on Saturday mornings after school. I'll eat breakfast and watch cartoons till like three o'clock and go outside and play till like nine o'clock at night and play football.

HANGING OUT WITH FRIENDS/ENJOYING LIFE (13%)

Walking on E-1. Me and Sean inside the music shop and playing football.

Have to say my favorite childhood memory was back in middle school when we used to mess around at the park every day after school. Play basketball, old friends and everything.

Being with my friends.

When I first rode my bike.

When I used to go to the Boys and Girls Club and play pool.

Just growing up and living to experience life.

VACATION (9%)

My favorite childhood memory is when I was seven. My grandmother took me to Disneyland. That was nice.

Probably my mom had this friend who's a bronze artist and they had this café up in the

middle of Wisconsin, in the middle of nowhere, Red Wing, I think. Just going up there in the summertime. It was really – it was one of those times that you know you don't have to worry about anything.

When I went to Disneyland. (*Q: With who?*) My mom. (*Q: Did you enjoy it.*) Yeah. (*Q: What made it fun?*) Seeing Mickey Mouse.

Going to Disneyland. (*Q: How was that?*) I would say it was extravagant.

SCHOOL (9%)

My favorite childhood memory would be me graduating from the 8th grade. It was, like, a big ceremony that they have.

First getting laid. No, I'm just playing. First time I learned how to read a book. It's all about the knowledge.

Being at my old school.

Just having fun times at my elementary school, Manzanita, with my friends that I still hang out with today.

BIRTHDAY PARTY (4%)

My favorite childhood memory was my fourth birthday party. I had it at The Jungle.

My favorite childhood memory is my brother's birthday party. I tried to go with them to the mall but I was too young. (*Q: How old were you?*) I had to be like six... five.

NONE (4%)

(*Shakes head "no"*) (*Q: Ain't got no childhood memory? Okay, what is your first memory of childhood that you remember?*) When my sister ran over my skateboard.

"I think, like, the last Christmas that me and my momma spent together. I think that will be it."

— *LaShawn Nolan*

LASHAWN NOLAN
DEWEY ACADEMY

What is the scariest
thing that ever
happened to you?

RIDING ON A ROLLERCOASTER

FINDING OUT MY MOM DIED

GETTING MY HAIR CUT

LOSING MY PHONE

FALLING OUT OF A TREE

SWITCHING SCHOOLS

SEEING A BIG ASS SPIDER

ALMOST DROWNING

BAD ASTHMA ATTACK

HEAD INJURY

BROKE MY ARM

NOTHING

ALMOST GOT HIT BY A CAR

HEARING THAT MY MOM GOT RUN OVER BY A CAR

HAUNTED HOUSE

GETTING LOST AT A MALL

SOMETHING DARK IN THE HALLWAY

WATCHING A SCARY MOVIE OR CELEBRITY GHOST STORIES

NOT DOING WELL IN SCHOOL

The scariest thing that ever happened to me? I actually have no "scariest thing that ever happened to me," except when I accidentally almost failed in the 4th grade. Because I knew that if I went on the wrong path that time, ain't no way of going back, and I wanna keep my head up.

Getting a whoopin 'cause I got suspended.

I got a bad grade once and I was scared about what my mom was going to do.

GOING TO JAIL

Going to jail for the first time would probably be the – or just knowing I was in jail and not realizing what I was doing. So, yeah. *(Q: And from that experience have you learned anything?)* Yeah, it's not too many people I would – I wouldn't say – be careful of just who you be with, y'know what I'm saying? Not everybody is loyal.

WITNESSING A SHOOTING

Seeing or hearing people get shot.

It was gunshots and I was playing outside. Then they start shooting.

When they shootin'.

I've seen a couple people get shot. Just seeing death. I mean, it wasn't nothing to be scared of, but you shouldn't see it. You shouldn't see it live, in the face, until it's you, you get what I'm saying? So, those – just basic, in the flesh, in the moment, ohmigod type of scary, it just – it ain't right.

I was in a party in Dubs, that's what we call it, the – the 20's, and a dude pulled out a gun and tried to kill somebody right in front of me.

When somebody tried to – it was when in L.A. and I was at my uncle Tay-Tay's house and somebody was in front of the house and they were shooting.

I watched my friend die in front of me. *(Q: How do you feel about that, at the time?)* Lost, confused, real confused, like... confused. *(Q: After the aftermath, after the shooting had been done, police came, how did you feel then?)* I felt like Oakland wouldn't just – it's not safe anymore. It's just, you gotta be careful at all times 'cause you never know what could happen. Just... always try to be careful.

GETTING SHOT AT

When I got shot at. Believe I was running around the lake and I guess it was the wrong time, maybe it was getting dark. I was running and I made it all the way around. Stay right over there on Eastlake, so I'm over here by the district. I start over here, where the construction is now. I go all the way around and I make it home. Basically, because I'm right where I started and I'm walking. I'm walking over here by the lake, over there by the tennis courts, over there by Merritt Bakery. And there is a one-way coming toward the lake and there is

that street that turns into First. So I'm coming up First and I'm right by the tennis courts. And up the one-way I see this Buick, burgundy, black tints. It's creeping and I'm like alright, I ain't tripping. I'm looking at the cars all the time. And I don't have any altercations or "beef" with anybody. I'm not really tripping. So I'm walking and I'm ready to make that left on the one-way. So they are coming this way in a car. I'm walking this way.

There's a parked car in between us. I see the car slow down as it gets two, three cars in front of me. So I start to get more aware of the situation. I turn my music off. I didn't take my head phones off, I just turn it off in my hand and put it in my pocket. I didn't slow it down, I didn't change up how I presented myself, my body language or nothing. So they wouldn't react irrationally. So I'm walking and I can see the car slow to a stop. A stop to a slow and it goes. When it stopped, before it made any movement, I knew in my mind that it wouldn't be a good situation. So I turned and looked at the light on First Avenue to see if there would be any cars coming. Just peep my surroundings right quick. And in a matter of seconds, I'm slowing down right quick so people could understand what's going on. The car stops and goes slowly, stops and goes. And he punches it and the window rolls down, and the tints make the inside really dark. So I could only see the hand of the driver. I could tell he was African American himself. And he was driving. I was looking at his hand, although the window had rolled down. I knew that is where the danger was going to come from. I was trying to pick up any details that I can get.

If I make it out of the situation I want somebody to be put in jail. I need justice. That is the only thing I'm thinking about at the time. In a situation like that, yes, you could think about your safety. But you're thinking about that person. That's your focus. That person wants me dead or he's trying to get something from me. I need to figure out what is going on with that person.

So the gun comes out, pop-pop-pop. I duck. I get behind a car and on the other side of the car I hear boom, boom, really heavy. And the glass shatters. I instantly grab my shoulder, I felt glass on my shoulder. And I look– I might have got hit. It looks like he shot three or four times and kept going.

He wasn't trying to kill me, I wasn't somebody he thought I was. It seems to me, after the situation, they were bored. The more I think about it, they were looking for something to do. They didn't have anywhere to kick it at. Let's go over here for whatever reason. They felt like shooting at me, so they shot at me. They didn't care whether I got hit or not because they never shot to confirm it. And I don't recognize the car, so it was definitely not from my neighborhood, because I lived here my whole life, 18 years. I'm familiar with everybody in the area. So I really don't feel like their intention was to take my life, but it was very close, and it's not something I can do all the way, say that's what they wanted to happen.

I'm thinking and wanting to believe they didn't want to take my life because I can't stand black on black crime. I can't stand the fact that we can't unite and stop picking each other off. I just came here from running around the lake. What could I have done to make them want to take my life? That is one of the scariest things I have dealt with in Oakland.

Most scariest thing that ever happened to me was staring down the barrel of a Glock 18 with a whole 30 on it asking, "Where you from, who is you?" Just 'cause I'm walking down the wrong street.

I got shot. *(Q: You mind me asking where?)* I got shot in Acorn and I got shot in Richmond. *(Q: At the time of the shooting, how did you feel?)* I felt afraid, I felt frightened and it's a shock, something I have to live with the rest of my life. *(Q: In going forward after the shooting, the aftermath, how did you feel then?)* Oh, I felt like... I can walk this whole earth.

This one dude, he hopped out shooting. I used to go to school with him, you know? Walking down the street, he hit the corner, I guess he had fonk with one a my partners that was standing with me. He hopped out shooting at him, so he was shooting at me too. It was point-blank range but I didn't get hit. *(Q: How'd you feel at the time?)* I was shocked... shocked.

I was going up 64th and MacArthur, and I was going to see a female and, on my way to see her, I got to six-four and Mac' and I crossed the street. I put my foot on that sidewalk and one of the guys that I used to go to school with, I had seen around, seemed as if he didn't know me, and he was like, "What you doing around here?" He was like, "It ain't good like that." And I was like, "What?" It stopped me – shook me up – like, "Who you talking to?"

I haven't really been into too much, so I'm thinking he wants to fight me. I'm ready to fight. I noticed that he had friends around him after he told me it wasn't cool like that, being around here. I got ready to fight, and that's not what he was ready to do. He told one of his friends that was close to him, "Let me see the clip." He had the gun on him already, and with him asking for that clip, I instantly thought, "Oh, it's time to get up outta here." And I ran. I don't care if anybody say, "He ran, he a sucka'." I don't care. It was my life on the line and I ran. I got up outta there. They didn't catch me.

This lady ended up picking me up and she told me, "hop in." I didn't know her, but my life was on the line. I didn't care. She was getting me out the situation I was in. So I hopped in and she was telling me to be careful, she was like, "Yeah, you gotta be careful around here." Her nephew just got jumped a few weeks back by the same guys that attempted to shoot me. She dropped me off at home. And that was the scariest thing I ever been through.

(Q: After dealing with all of that, how did you feel?) I felt like what my mom had been telling me, I should've paid attention to. Girls ain't everything and there'll come a time when you meet the right one, but I was kinda like, I ain't been through what she telling me about so let me do what I wanna do. I was rebellious, you know, I went against the grain.

LOSING A LOVED ONE

First time I found out my mom died. That was the scariest thing. My sisters were there and I didn't know what to do. I didn't know to cry. I was like, my mom is gone, what I'm supposed to do? And that is being a big brother. *(Q: At the time, what was going through your head?)* My mom, really. At this time I was like, alright, what is there for me to do? What is my next step? I know I'm going to cry in a minute, that is my number one step. What am I'm supposed to do right now? What is the thing that would define my future as a man at this moment for my sisters?

Who is the most successful person you know?

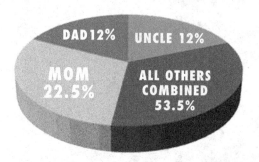

DAD 12% UNCLE 12%

MOM 22.5%

ALL OTHERS COMBINED 53.5%

"The most successful person is my mom and my dad. *(Q: Why?)* Because it feels like one day I can be just like them. *(Q: What does your mom do?)* My mom does – she is a custodian."

— *Carlton McWoodson*

MY MOM – 22.5%

I hate to be corny but she has always overcome and always been strong. She is success.

Probably my mom because she goes to work every day and does what she has to do.

Mom. *(Q: Your mom? What makes her so successful to you?)* 'Cause she always helps me with everything I need.

I'd say my mom. My mom – she's a substitute teacher, she's got her BA. She's still working toward being a permanent teacher. But she raised two kids, she raised two sons on her own. And I see young women out there with one kid and I hear about the struggle and I feel like she's the most successful person that I can see right now in my life, like the person I can reach out to.

MY FATHER – 12.5%

The most successful person I know is my pops. I feel like pops is a hard working man. Pops is a single father of three. One of them isn't even his. You know how many people – men, run away from girls that say their child is on the way?

My pops, he is a great man. He graduated high school, didn't go to college and has been working since he was 18. He is now 46 and he is going strong. He worked at McDonald's. He worked at a body shop. He did pipes. He worked in the plant. Right now he is currently working as a mailman. Working 12 hour shifts. It never ends for him. Never ends.

Yet he still has time to make sure his sons are where they need to be, education wise and safety wise. He makes sure that his sons are never hungry or deprived of any basic need that they need at home. Pops made sure that his sons understood that the decisions that they make now can and will affect their future, just like it affected his. He always regretted not going to college or furthering his education. So his best wishes is for us to be the better person and further our education to make sure our life isn't full of hard work. We need more easy work, more compassionate work, more efficient work. Pops is very inspirational. When I think of pops I don't ever want to let him down.

My dad. *(Q: What makes him successful?)* That he paid attention to us. And when he wanted to play with us, he'd play with us. And when it came to playing or doing your homework, he'd go, "do it." He'd ask us if we had any homework over the weekend and then we'd say no. He'd go to McDonald's and buy something and if we said no, I mean yes, that we got homework, then he'll call my mom and ask her, "Can I get the keys to the house?" He'd go get my backpack and stuff, my homework, and on the way there he'd go to McDonald's to get us some food and go back home.

My dad. *(Q: What makes him successful?)* He likes to do stuff with us. *(Q: Okay, what kind of stuff does he like to do with you guys?)* He likes to take us outside and take us to the skate park.

MY UNCLE — 12.5%

I come from a family where, you know, a lotta people are successful. I'm not trying to be a bragger or trying to front or anything, but I would have to say my uncle. He played professional football. His name's Joe Abdullah.

Most successful person I know is probably my uncle, 'cause he feels like his life is kind of just steady. He takes care of everything, not falling behind. He knows what he got to do and he gets it done.

I'd say my uncle, I would have to say my uncle. He owns his own club and owns his own security.

MY GRANDMOTHER — 5%

The most successful person I know is probably my grandmother. And she's successful in pretty much every sense of the word. She has made a nice life for herself. She is her own person. She is a nice lady.

I know a lot of successful people, but I say my granny, because she overcame a lot to be where she's at right now. She went through a real struggle. She's successful right now. I'm very proud. Shout out to granny! Clap it up for her.

MY AUNT — 5%

She helps me with my homework if I need help and she's the one who made me go to afterschool.

MY COUSIN — 5%

I would say my cousin. She just graduated in 2012. Senior year and I don't know her college plans, but she's been working a lot and saving up. And she is my age, a few months older. Who couldn't relate to that one?

MY TEACHER/MENTOR — 5%

Actually, my god mom or my mentor, Debra Day. What makes her successful is her willing determination. She started off with one... just one small idea and one book and from that book and that idea she went and made a full, a *full* company from it called, *A Shade by the Bay*. And I mean, it's filled with thousands of children's books and it's very amazing. I would say she is the most successful person. *(Q: Did you ever think* the only thing is I'd rather not follow in anyone's footsteps. I'd rather make my own.

The most successful person that I know is Mrs. Maririz *(Q: Why?)* Because in 3rd grade she helped us and taught us more

things and different things to get us ready for 4th grade.

FAMILY, IN GENERAL — 5%

My mom, and my dad, and my sister, my brothers. (*Q: Okay, what makes them successful? Whichever one you wanna pick.*) They love me. My mom and my dad. My auntie and my uncle because they always tell me the right thing. Not to lie and to get a good education when you go to school. And always keep your head up and just focus in class no matter what. And they tell me sometimes, anything that happens, just walk away or tell the teacher. Don't let anything go through. Just tell the teacher, 'cause if you don't, when you grow up you gonna be in jail, you gonna be there maybe for your whole life.

BARACK OBAMA — 2.5%

The most successful person I know is, man, I would say Barack, 'cause coming from a black dude, it's hard to get up in that White House, you feel me?

MARTIN LUTHER KING, JR. — 2.5%

TUPAC — 2.5%

I would have to say my family and otherwise I would have to say Jay-Z. (*Q: Why?*) Naw, Tupac, because he accomplished his complete goal and that was to have his name recognized by the world when he passed on and to have a social impact on the world when he left. He was so successful, he accomplished his one goal, over money and everything, that one thing he wanted to do. (*Q: And what did you learn from that?*) Regardless of how you pictured your life, you have to keep striving. You know, like how at a funeral is the one place where the good that you do is better than the bad. If your achievements are quiet, they're going to be quiet at the altar. That is not how I wanted it to be.

WIZ KHALIFA — 2.5%

BISHOP ANTHONY WILLIS — 2.5%

He came from a lifestyle just like mine, using coke, pimpin', doing a whole bunch a stuff, you feel me, and now he just a man of God. He do the work of the Lord, which is honorable to me.

STEPFATHER — 2.5%

The most successful person I know is my stepdad. He was a professor and he worked for 30 years and he instructed my brothers. Anytime they were feeling down about themselves he would give them encouraging words, like, "You can do it" and stuff.

FAMILY FRIEND – 2.5%

BABY MOTHER – 2.5%

My baby mom, because she completes everything that I haven't – something I never had.

NOBODY – 2.5%

Right now I don't know anyone. *(Q: You don't know anybody successful?)* No.

MY BROTHER – 2.5%

My brother because he got A's and B's like my dad.

MY GRANDFATHER – 2.5%

The most successful person I know was my grandpa because he did what made him happy. He did what made him provide for his family, because family came first, and his ambition came first.

If you could change
one thing about
your school, what
would it be?

"To make everyone stop being mean."

STUDENTS – 33%
CURRICULUM – 12%
DISCIPLINARY PRACTICES – 10%
TEACHERS – 10%
NOTHING – 10%
LUNCH – 8%
BIGGER SCHOOL – 4%
LONGER RECESS – 4%
MORE TIME AT SCHOOL – 4%
OUTREACH TO AFRICAN AMERICAN STUDENTS – 2%
COST – 2%
NO UNIFORMS – 2%
MORE FUNDING FOR SCHOOL – 2%

STUDENTS

Bullying.

Change the violence.

To make everybody stop being mean.

Stop getting mad at each other. *(Q: Why is there a lot of people getting mad at each other at your school?)* Because people keep bullying and we need to stop that.

The name calling. *(Q: And why?)* Because it's not good for our community, because people should feel safe in the school community without being called names. *(Q: Did somebody call you names?)* No. *(Q: How do you feel when you hear other people call your friends names?)* Sad. Mostly sad because they don't know what goes on in that person's house and so it is kinda like personal what goes on in their house.

WASTING TIME

If anything, if I could just magically change anything, I would change the way some students think. I think some students need to grow up. That's what I think. And take it more seriously, like when I was in the younger ages – like, I'm a senior now, but when I was younger I didn't – I was thinking like them, like, I got time. But I would tell 'em, you know, don't waste time.

CLIQUES

Have to probably be the cliques. People is in their own different cliques, everybody in their own different zones, their own different comfort zones, their comfort zone. I would like to be more diverse to where it's not about the diversity drug-wise. Not all people talking about, "Oh yeah, I only hang out with this person because they give me some weed. They give me whatever I need." I want them because they want to hang out. They don't want to hang out because of what somebody else has. They don't actually be friends. I'm color of the rainbow for friends. I hang out with everybody because I want to. It's like that.

I say… the… what's that one name that – I can't think of the name, but it's the people that organize, like the rally and stuff… them, 'cause it's all Asians.

Well, right now I'm not in school. But when I was in school – I went to school in Vallejo, California, it was a lotta discrimination between races. The Asians would be on this side, the whites be on this side, the majority of the blacks be on the top of the stairs, so it was separate, no unity. *(Q: How did you feel at the time?)* At the time I wasn't really worried about it, but I knew it was an issue, but I never really addressed the issue at hand.

LACK OF DIVERSITY

The diversity at the charter school wasn't really up to snuff. I felt a little bit, you know, I like to stand out, like to be unique, but that was a lot.

CLEANLINESS

One thing I would change about my school is people not being messy but being clean.

CURRICULUM

Less homework.

More parties.

If I got to change one thing about my school I would change it so kids do more math and science.

Do more stuff.

More field trips.

More field trips. *(Q: More field trips?)* Yeah. *(Q: Okay, what would be one of the field trips that you would like to go to?)* Probably science, science and museums.

Make the school bigger.

DISCIPLINARY POLICIES

I would change OCS 'cause that's a bad thing and that just brings the kids down, and don't make them want to work hard, it just makes them wonder why they're in OCS.

I don't know, 'cause I'd change the disciplinary thing because some kids – they get in trouble a lot. And so they're quicker to get sent out of class than other kids because they have a bad rep.

Kids can't – they have to write a sign from their parents to the school that they're gonna walk home today and they're gonna walk outta the school guardian, like off the campus and walk home. *(Q: Oh, so you want them to write a note?)* Yeah. *(Q: To let them know?)* To let them know. *(Q: Why would you want that to happen?)* Because some kids could get shot. They can get involved in something, and a lotta kids walk to a lotta culturally violent places.

People that be bad... tell the principal.

"I'd change tardy sweeps. Tardy sweeps are wrong. *(Q: Could you expand more?)* Tardy sweeps, like when you come late, they, no questions asked, no reason, but we'll have to go in the room – we'll stay there like the whole day, and that's not good for students when it comes to their education. Might or could be a serious emergency but..." *(shrugs shoulders)*

— *Leonard Moore*

TEACHERS

Probably the teachers. *(laughs)* Most likely the teachers, that's what I'd probably change. *(Q: Why would you say the teachers?)* I feel like some teachers can be more... how can I say it? More "at us." Y'know, more real. Instead of being like, "This is what you have to do," could be more into us, like push us more. Like real life be *on*.

Not parenting, but like a mentor that's like a coach. Instead of a teacher, you know what I'm sayin'? Be more of a coach. Get real harsh on us.

"Man, my teachers – like, my professors... they be kind of unorganized. So, if my professors could be more organized with the class work, like, showing up to my class – the students show up to class more than the professors. So if they got on top of that, everybody will learn better. Know what I'm saying?"

— *Terrell Toliver*

Man, I would change the fact that the teachers sometimes just don't care. It takes a teacher to reach out to a person, for a person to really learn something, not just hand them a paper.

Man... staff.

Better teachers. *(Q: Better teachers? Why? You don't like the teachers that are at your school?)* No, they're okay, but more teachers that have more education than those teachers.

NOTHING

Actually I wouldn't change anything. Dewey is one of those schools where you have your good times, bad times, exclusive times. But you have a time. Dewey is one of those places where you will learn, you will stay focused. You will dedicate yourself.

At my school, Dewey, well to be honest, Dewey definitely isn't what people make it to be, so I definitely want to start off by saying Dewey is a great environment. Full of adults and staff members that actually care about the students, rather than any other high school I visited. And I feel like if there needed to be a change here, I feel like the students that come here change the perspective of the school. So, that they come here to work. They come here to change. And they come here to make a better person of themselves, because this is a second chance. If you, for whatever reason, cannot make this happen at Dewey then there is obviously something wrong. And you really need to think about that before trying to walk into this campus and disturb everybody else's education.

Actually, I wouldn't change anything. I really like my school. I feel like they really welcome me and it's a great environment and I enjoy all the people so, I like my school. I wouldn't change anything.

LUNCH

Probably be the lunch. That lunch is not shmackin at all, I'm not gonna lie. Stale bread, y'all gotta get rid of that, I'm not gonna lie.

The lunch. *(Q: Why?)* Because, like, well, I know that... the quality was worse at the elementary school I just graduated from and it got a little bit better... but sometimes it's just kind of bad and I actually went to the actual kitchen where they make the food

on a field trip and if they cook it on Tuesday, you eat it on Friday and they just put it in a refrigerator and then heat it up really hot and put it in a plastic bag and serve it to you.

The cafeteria food. *(Q: Okay, what would you wanna eat for lunch?)* Domino's Pizza. *(Q: Domino's Pizza? What kind of pizza?)* Cheese. *(Q: Cheese, just everyday for lunch?)* *(nods head and smiles)*

LONGER RECESS/LUNCH

How long the recess is. *(Q: How long would you want it to be?)* Two days.

MORE TIME HERE

It would be the time we spend here. *(Q: Could you elaborate?)* And it would be more time we spend here. I would want more time to be at school. I feel like it's too little sometimes or just a lack of attention.

My school? If I could change one thing about my school it would just be that I coulda' went there earlier. My school – love my school, Dewey. I only been there like four days. I been at Tech. I only been to one high school in Oakland and that's Oakland Tech. I've been there for the last three years, but as soon as I got to Dewey it's like – it's not even that it's easy – I understand it more. Like when I do the tests, I actually remember what to do. I really feel like it's knowledgeable – it's a family. What school has dance parties on Friday? Come on now, it's just the best. It's the best.

OUTREACH TO AFRICAN AMERICAN STUDENTS

Probably outreach. Meaning how many students actually participate that are black. It's pretty diverse, just not many black people. Right now I take a communications class and I think there's about five black students in there.

EXPENSIVE

Berkeley City College. I'd make it free. Can we please just get some free education? *(laughs)* Ohmigod, the bills just keep coming in.

NO UNIFORMS

MORE MONEY

The money, so we can have more technology and stuff like that. *(Q: If you had the money, what would you do with it?)* I would probably buy better equipment for recess and more stuff for the classroom.

Do you plan to
go to college?

DO YOU PLAN TO GO TO COLLEGE?

I want to be the first in my family to graduate college with a masters.

I definitely plan on going to college. It sounds unrealistic but I feel like I'm going to dedicate more than half my life to furthering my education. I have this power, this will inside and this hunger for knowledge.

I plan on going to college so I can be the best at what I want to do.

Yeah, I plan on going to college just to show that just 'cause I'm black, I'm smart, I'm intelligent, and I'm goanna make way more money than some Caucasian thinks I'm supposed to.

Yeah. *(Q: You do?)* Mm-hmm. *(Q: Why?)* Because I wanna go to the NFL and get good grades. And one day teach my own kids to be good.

Yes, I plan on going to college because I plan on inventing something and changing the world with it.

Yes. *(Q: Do you have any college in mind yet? Do you know what you want to be?)* No, I got too many things. *(Q: Like what?)* Like a football player, an actor, or karate man, or a basketball player or accountant.

Yes. *(Q: Why?)* So that I can get my education, grow up to be an African American man.

I do and I'm in college right now. I attend Merritt College and I've been there since '08. I'm not the best student, but I understand that having a degree will get me somewhere and I'm about six classes away from graduating. I'm still pushing. *(Q: Congratulations. What do you wanna study – or your intended major?)* Right now I'm a social and behavioral science major and I'm interested in psychology. I'm very interested in the way people think, the way people do the things they do, and the reason people react to certain things the way they do.

100%

YES

Do you plan to
go to College?

NO

0%

"Of course. You know, I'm a black man.
Of course I am going to college."

— *LaShawn Nolan*

LASHAWN NOLAN
DEWEY ACADEMY

GOLDEN GATE FIELDS

GABRIEL CHANEY

DOWNTOWN OAKLAND

CHAPTER THREE

[BEING] AFRICAN

QUESTIONS AND ANSWERS

WHAT DO PEOPLE NEED TO KNOW ABOUT AFRICAN AMERICAN MEN IN OAKLAND?

WHAT IS IT LIKE BEING A YOUNG AFRICAN AMERICAN MAN IN OAKLAND?

HAVE YOU EVER FELT ASHAMED OF YOUR CULTURE?

TELL ME A TIME WHEN YOU FELT PROUD OF YOUR CULTURE.

AMERICAN

What do people
need to know
about African
American men
in Oakland?

WE'RE NOT ALL THE SAME/DON'T JUDGE A BOOK BY ITS COVER

If it's more than three black hoodies – don't go near them. We're not all the same. There's huge diversity in how we grew up, how we still growing up. There are some that will take care of their own and those who will fend for themselves. Definitely not all dead beats. We have our dreams. Even the ones in gangs, they all have a dream, a better dream for their life, they just don't know what to do with it. They have so many expectations, so many things they would like to do with their lives, but the fact of the matter is, the economy is terrible, awful. And usually growing up around this stuff, you kinda forced into it. You have nothing to do, you don't have hope that you could do anything better for yourself. So we're not all the same, we're totally different. We have different mindsets. It's what you do with it.

Watch them. Please watch them. They can be the most sweet talking, most evil, most lovely, most beautiful, most ugly people in the country. Because there are some that naturally believe in the good of the women and in the world and then there are some who are naturally just disguised as a con man. Oakland African American men really have a way with words and you watch them and listen.

There are a lot of us and we're individuals. Just because someone looks one way, don't be too fast to judge. I'm guilty of that. I'll judge my brother on the street on occasion. Sometimes you're not feeling as good and open minded as you really should be and you make judgments. But I think people should know that, just like everybody else, everybody is just trying to make it and not everyone has been given the same privileges and blessings as everybody else. So, just, you know, remember.

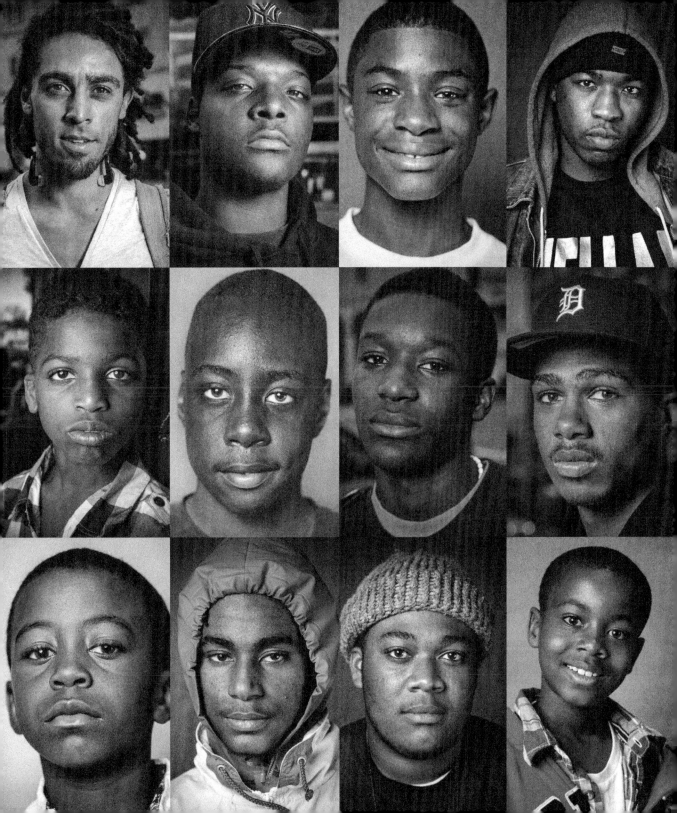

> "You need to know that African American men are proud of themselves and don't necessarily hate each other. It's a stereotype that we hate each other. We don't hate each other. It's all love at the end of the day."
>
> — *Aaron Johnson*

Not to jump to conclusions and don't judge a book by its cover, because everybody is different. And everybody is not just that dude on the music videos you see trying to get money and get hoes. We are successful and intelligent.

That they not always about drugs and killing. That some have talents, but you just gotta give 'em that chance.

That some of them kill each other.

Sometimes white people need to stop. They need to know that white and black is a great color and black is not a bad color. 'Cause one time one of my friends said, my mom asked him, "Do you like black?" And he said no 'cause he didn't know, he was talking too fast. They said don't ever say that, because young black men's color is a great color.

That the majority of us are not always stereotypes, y'know what I'm saying. There's quite a few people in Oakland, that I know personally, that have a good head on their shoulders. Going to work every day, don't even do drugs, don't even like the smell of cigarettes. So that's what I look at as my African men.

WE'RE ALL GOOD/SMART/LOVING/STRONG

If we don't like something, or, if something's going on, we gonna speak our minds, whether you like it or not. It's just how we feel – and it's not to offend you, or nothing like that – it's just to, you know, to clarify what's going on.

That we're all good. We're good creative beings and we're all very empowered. And we're all individuals. I think Oakland kind of has a bad rep, especially the black community, which kinda takes the most of that. We're all not bad. We're all out here doing our own thing, trying to make it better - make Oakland and ourselves better.

We just cool. It's Oakland, ain't nobody like us. We're the last of a dying breed. There is nobody like us out here. Whatever your type is in Oakland, in men, females, you're going to find them. It's good out here in Oakland, we... a couple knuckleheads, that's why we got a crime rate – a couple of knuckleheads. But besides that, everybody's – we cool out here.

That we're strong.

That we are strong and that we have a backbone.

They are good and they ain't gonna hurt you.

That they're grateful and they have — sometimes some people have a hard time.

What people need to know about African American men in Oakland is that they are proud of their skin color.

They need to know about African men, because some African men help us and are bold and brave.

Our history. Because there is a lot of black people and we have knowledge. That there is hope. There are strong minded individuals. They're our families, they're all our people that do have potential to be very great men and women and have the potential to help you.

We're excited, with a lot of energy.

It's hard out here for us.

That it's hard out here for 'em and... that's about it.

They need to know that it's hard to be in our shoes. That you gotta face all these struggles *and* stay on your school work *and* focus on not going on the wrong path *and* stay on the right path to greatness.

Oakland is kinda messed up right now, but the people that live in Oakland is not messed up.

WE'RE MISUNDERSTOOD

People don't understand African American males. The power they have to create change is so high. They underestimate what we can do. When I walk down the street, a lot of the times I get looks from people. Should I cross the street? There are a lot of assumptions but when you really get to know and learn about these men, these young men, you find out that they aren't much different. Because of their color, because of where they came from, it creates a more genuine person. These "hoodlums" that everybody is afraid of, they have a lot of good inside of them that this community needs. Just for the simple fact, that what they have been through is something that nobody else has. And that contribution is important, because that is the missing puzzle piece — the understanding we never got. That's the confirmation. And that still needs to be confirmed.

That they are going through something, even though they don't look like they are.

African American men in Oakland is not considered, you know, what you would call ignorant, not what you would call stupid, that's just not the case. They just need a way out.

They need to know that we can do better than they think we can do.

That they're not all what you hear on TV. They're not all shooting and robbing banks and stuff. And they're not all on drugs and all that kind of stuff that people think. Yeah. That's what I think all African Americans or Americans should know.

That we don't all run around shooting each other and killing each other.

"That they're smart. Every black kid in Oakland is smart. Young men too. 'Cause, to maneuver out here and stay outta trouble, keep your name, depending on what you're doing, and keep your name off the streets and people not wanting nothing with you, that's – you gotta be a smooth guy. Really."

— *Miles Jones*

People need to know that just because African American men look funny, doesn't mean they don't have great skills. Like Kunta Kinte, they thought the wrestler was just an ordinary slave, but the wrestler had these skills to wrestle, to fight back no matter what.

That they're not Negros. *(Q: Okay, what do you mean by that? Like, they're not slaves anymore?)* Yeah.

What is it like
being a young
African American
man in Oakland?

OVER 13 YEARS OLD

UNDER 13 YEARS OLD

HARD

83%

GOOD

17%

GOOD

79%

HARD

21%

IT'S HARD

That's tough. That's definitely tough. Like I said, a lot of them are misunderstood, including me. It's really tough because you can't wear a certain color, you can't do certain things without getting looked at funny. You can't really do anything without having some kind of eyes on you that will make you feel weird. Make you feel sketchy, like, what am I doing?

It's hard. Definitely hard. It seems like everything is a competition. It's a lot of jealousy, rather than respect. And it seems like everybody is an enemy because you come from a different area. It seems like regardless of how much we have in common, we see differences. And for an African American male it is dangerous. If you don't take advantage of school and opportunites given to you, you will be put out into a world that will turn you inside out. It will eat you alive. That world out there is sick. And African American males go through so much when they aren't in school, when they aren't at home, when they are at home. And I feel like not too many people understand the extent of the cruelty they deal with mentally.

It is hard because some black men can't get no job, because the way their household is or the way they carry theyself, or something like that. But all you gotta do is just keep your head up and keep going forward and everything will be good. Don't, don't take no for an answer.

Man, it's hard, a lot of harassment. Cops won't stop driving back and forth behind me. I feel like I'm gonna get shot just 'cause I got a hoodie and some Skittles.

It's really hard... it's really rough. It ain't easy being a black African American male. See, me, I'm a good positive person and I love people period. I'm a people person, but other type of people look at me and walk past me and, y'know, mean mug me or look at me like I might be a threat. Down by Lake Merritt yesterday, for me to find my way to Grand Street. I'm asking somebody, "S'cuze me, s'cuze me, s'cuze me" and they just ignoring me. I'm like, wow, I'm not asking for no change, I ain't asking for nothing. I'm just trying to ask you for directions.

It's hard 'cause when you walk into a store, everybody thinks that you gon' do something wrong or bad just because of other people of your skin. And they gon' put you down just because of the color of your skin. Just being African American.

It's hard 'cause people look at you with negative thoughts and you gotta turn them into a positive.

"Sometimes it means people will treat you differently. Sometimes it means you need to be courageous and you need to know who you are and what you stand for."

IT'S STEREOTYPED

It's not the same thing as growing up in Antioch, or growing up in San Leandro or something. People expect you to do different things. Expect you to be in certain statistics. It's all about expectations in Oakland because we got a reputation for certain things. *(Q: And that reputation is?)* Oakland statistically, I read recently, is one of the fourth worst cities in America to live in due to violence. Statistically, they expect African American males to feed into that statistic because we do.

IT'S COOL

I think it's probably one of the better places to be a young African American male. I mean like, if I was in Nebraska, I'm sure it wouldn't be so fun. *(laughs)*

It's good. I think as you look around and you see that there is more and more diversity in the African American community – not everybody is one way. And I feel like that's just getting more prevalent and I think that's something great to be celebrated. And Oakland is just like an epicenter of people mixing and doing their own thing and nobody having to really worry about them. People have their own lives around here, so they just worry about themselves.

It feels good, because then you can help other people in your community.

It is great being a young African American in Oakland. *(Q: Why?)* Because you get to explore new things and have fun.

It's a good thing, being a young man, a black, African man living in Oakland. It's a good environment, people respect you more, people don't look at you funny, everybody comes together and get along and do things.

It is fun because I don't have to get judged by my skin color.

It is what it is.

Have you ever
felt ashamed of
your culture?

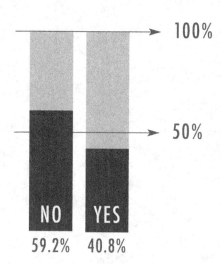

100%

50%

NO | YES
59.2% | 40.8%

NO

Ashamed of my culture? No. I feel that they can do better, but I wouldn't say ashamed. Everybody makes mistakes.

"Not at all, not at all. Uh unh. *(Q: Not at all?)* What kind of dude would I be?"

— *Cleo Senegal*

Never. *(Q: Never?)* Never.

I never felt ashamed of my culture. I just felt disappointed, I just feel like we could do better. It's nothing wrong with us, we're not bad people, it's just – when you grow up it's like this; if you take a young black man to China for 12 years, eventually he gonna start speaking Chinese, right? You take a young black man and you see crime, selling crack, sex, drugs and people wanna party, all that. Eventually he gonna want that life. So I'm not, I've never been ashamed of my culture, I just feel like we could make better decisions.

It's a good thing, being a young man, a black African man living in Oakland. It's a good environment, people respect you more. People don't look at you funny. Everybody come together and get along and do things.

YES

I mean, living in Oakland, it's kinda hard not to, because the majority of things that happen are usually by black people, especially people that are in West Oakland that bang certain gangs. They start giving kids guns. Seriously? I know a 10-year-old with a gun already. Like, come on man. That's not okay. They grow up around this and they start banging their own cliques and now Oakland is at war with itself. It's falling apart. Every day I live here I see something new that makes me more ashamed of it. We could do so much better and we ask for equal rights and we working for it, we showing we're animals. It's not healthy.

Yeah, because African American people are filling up the jails right now.

I was going to say no, but when I think about it, there are many men and young African American males that make it hard for others to respect us. Their actions don't comprehend well, I should say. When I do things, like, I participated in the student Fishbowl at the Chabot Space and Science Center, and joining the Urban Peace Movement, and being a peace ambassador, and I step on campuses other than mine, Dewey, and I interact with others and I see where they have come from. I see that they have been through a lot to make them better people, yet they shut it out. It seems like purposefully they shut it out and I have yet to figure out why. But I can tell they do it purposefully for whatever reason. I don't understand it.

"I'm definitely ashamed of how a lot of African American males are being provided with everything they need to be successful, but they don't embrace it."

— *Mario McGrew*

Yes. I feel ashamed all the time when I see black men or black women being loud, you know, just for no reason or what they call "ratchet." Ratchet, you know, I just feel embarrassed every time I'm around that.

I feel ashamed of my culture when I see young dudes cussing and stuff and cutting up around older people. You have to show a little bit of respect.

Yes, because I remember that people think I always do wrong. But they don't think that I take my education seriously, that I just goof off, and just wanna be a sports player, or just a rapper, but there is more to me. I wanna be in *Criminal Justice,* or like an *American Therapist* and everything else.

Well, once I have because everyone kept on laughing at me because of the way my, because of my family's color. *(Q: For real?)* Yeah.

I feel ashamed of my culture when we don't appreciate one another, when we kill each other off. For example, every time I look on the news it's... I always hear something, like a young black male shot in the street. That's when I really feel, like, ashamed of my culture, 'cause we don't know what we can really do, but instead we put our anger out on each other for petty stuff, for petty change as well.

Tell me a time
when you felt
proud of your
culture.

EVERY DAY WHEN I WAKE UP AND LOOK AT MYSELF IN THE MIRROR

BLACK PANTHERS MOVEMENT

WHEN I WAS BORN

BEING IN THE MANHOOD DEVELOPMENT PROGRAM

WATCHING THE BET AWARDS

DURING BLACK HISTORY MONTH

CELEBRATING KWANZAA

TUPAC

NELSON MANDELA

SUCCEEDING AT SCHOOL

WHEN WE HELP EACH OTHER AND STEP UP IN THE COMMUNITY

WHEN WE STOPPED BEING SLAVES

WHEN BARACK OBAMA WAS ELECTED PRESIDENT

WHEN WE WENT THROUGH THE CIVIL RIGHTS MOVEMENT

MARTIN LUTHER KING, JR.

Almost every day, almost every day. Just being out and seeing that things we've done have set trends. I was just at the mall the other day and, it was crazy, I'm at the mall and I'm purchasing a pair of jeans and a Mexican came through, and he got the music loud, like he walking through the mall. He got his stereo in his hand, and he's slappin' Lil Boosie, like, loud while he's shopping. And I just – I thought okay, we influencing people. I saw what he was doing, it was kind of negative, and maybe a little ignorant, but I figured, if he was slappin' Lil Boosie, and Boosie is African American so... it amazed me.

When I was in the Oratory Fest. It was me, my friend Gregory and Michael, and we won first place. *(Q: Was it poetry?)* We did poetry and we went against other people.

When I went to camp, an all-African American camp, just nothing but black kids, and I just seen, like, actually how many kids and how easy it is to get along with African American people.

"When my uncle was still alive – he was Huey Newton and he did a lot of positive things for our black community. I was proud to be a black African American then. *(Q: Such things as?)* Meals on Wheels, No Child Left Behind, things like that. I mean, just – just doin' positive things in the community, just trying to help people out, period. And just thinking about how they are, it didn't matter who you were.

It's all about just coming together and – the only way we can change the world, only way we can change our neighborhoods, only way we can change our community is by coming together. We have to all have an understanding and everybody has to be willing to put in an effort to do the right thing."

— *Joshua Neal*

When I was born I was proud of my culture.

Probably graduation day. Seeing a whole bunch of people, different races and everything, doing their thing, taking care of business, doing what everybody should be doing, making an example.

KITO & JAMES
MARTIN LUTHER KING, JR.
ELEMENTARY SCHOOL

CHAPTER FOUR

COMMUNITY

QUESTIONS AND ANSWERS

COMMUNITY IS...?

DESCRIBE YOUR NEIGHBORHOOD.

IF YOU COULD CHANGE ONE THING ABOUT YOUR NEIGHBORHOOD, WHAT WOULD IT BE?

DO YOU HAVE ANY ADULTS YOU CAN OPEN UP TO?

WHERE DO YOU FEEL SAFE?

WHAT DO YOU LOVE ABOUT OAKLAND?

WHAT WOULD MAKE IT BETTER?

Community is...

Community is...

Culture

A well oiled machine if put together right

Broken

Unity

Communication

Where everybody come together as one, and just chills

Messed up right now

Special

The environment you feel most comfortable in

Family

People

Everyone sticking together and doing something together,
to strive together, to succeed together

An environment put together to work

GREAT

A neighborhood

Unity

One of the best things you should have

A place with people in it

A little, little place where everyone's connected as neighbors

Important

A group of people working together, trying to make a new thing happen

A place where you usually see the same faces every day

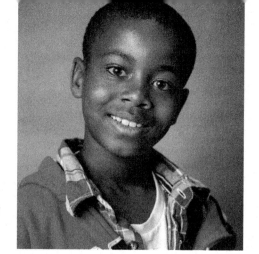

> *"*Community is a helpful place with wonderful people.
> *(Q: Do you feel like that about your community?)* Yes.*"*
>
> — *Alonzo Holmes*

A neighborhood

Good

When every individual comes together to work as one unit, and we all look after each other

Environment

I don't really know how to answer that question

Community is a helpful place with wonderful people *(Q: Do you feel like that about your community?)* **Yes**

My dad

Community is a thing that all people no matter what color they are, come together and are one happy world

Community is when we are all together

Community is a group of people talking and laughing and enjoying their lives

Important. *(Q: Why?)* **Without a community – no team**

Life

Neighborhood, family, in a way. Everyone know each other

Community is a well oiled machine if we put it together right. *(Q: Could you explain more on that?)* Community, to me, means people that work together to accomplish the same goal to keep the peace and harmony, just to keep it together. If it's not put together with the right, with the right components, then it will fall apart and we will start going to war with each other.

Community is broken. *(Q: And why do you say "broken?")* Because, you know how community is supposed to be love one another? So far the community has been against each other. So really, there is no point of community, so it's broken.

Community is unity. I feel like there is no individuality in community. I feel like if a community is to be successful it needs contribution from everyone.

Messed up right now, man. It's a lot of unemployment, poverty, all that. So people need to get on top of that.

Community is special. *(Q: Why do you say that?)* Because when it's – when there's that synergy and when everybody is doing their part and has a good positive outlook, if you will, it can be really amazing. Community can do amazing things, but everybody has to have the right mindset.

Community is the environment that you feel most comfortable, the environment that you feel most safe, most relaxed, most free basically. Community is s'posed to be built on a strong foundation of family and some type a morals – if not any at all – just some type. You can't be a community if you killing each other in the same community or the same environment. You can't. It won't work out like that.

Danger, sometimes. *(Q: Danger sometimes. Okay, why does that come to your mind?)* Because people get shot, and I don't want to be getting shot, and I don't want no one else to get shot.

Oh, it's dangerous. *(Q: Dangerous? Why do you say "dangerous?")* 'Cause they be shooting around my house and in the world.

Community is... *(pauses to think awhile)* is about picking up trash and if somebody's sad, make them happy. If somebody thinks something's hard, you can, like, help them... and if somebody's crying, don't like... *(shrugs shoulders).* Make them happy again.

Community is good because we can – people –black folks and white folks can get along.

Community is, well, *(pausing to think)* ...basically, when we talking 'bout community, our community is basically Oakland. It's a perfect place to live. Where people thinking Oakland is a bad place. Oakland is really not a bad place. It's the people that's living in Oakland, I mean people that's doing the violence. That's what's wrong with Oakland. Other than that, Oakland is a beautiful place where people can come and live their lives.

Community is a family, y'know, everybody that's from the same neighborhood, or different neighborhoods but, it's still a family.

Please describe
your neighborhood.

EASTMONT MALL

East Oakland, 81st Street, it's a cool place. Well, not really too cool but, you know, I'm hangin'. S'alright.

Mmm, it's fun but it's dangerous too.

EDNA BREWER MIDDLE SCHOOL

Peaceful, and kinda crackheady-ish, 'cause there's a lotta people – well, it's not like at my house, it's like in the other apartment. It's like a whole other apartment complex and there's a lotta people that smoke and stuff.

There's always people walking around or people jogging and usually there's kids playing down the street.

Noisy. A lotta cars go down the street.

My neighborhood is a good neighborhood. I have a lot of friendly neighbors.

It's nice. Not, like bad, with bad influences or anything. Pretty good.

A little ghetto.

It's on a hill, at the top and there's not much stuff that goes on up there because no one goes up there to do anything except a couple things, so it's nice.

It's a lot of different races... I can't remember the word right now, but it's just real racial.

I guess you could say it's nice.

Predominately Jewish and lower middle class.

Cool, not too loud, calm.

MARTIN LUTHER KING, JR.ELEMENTARY SCHOOL

Quiet.

Nowhere to park, so we just try to squeeze in somewhere. Just squeeze it.

My neighborhood is a good neighborhood 'cause nothing's bad, or nothing wrong with my neighborhood. My neighborhood is excellent because I have – I have everything I would need to have a good neighborhood. I have good neighbors, good friends, and all these people I can rely on if my parents aren't home.

It's a lot of kids and sometimes it's violence.

Where I live, it's kinda like where they come shoot.

OAKLAND TECHNICAL HIGH SCHOOL

In my neighborhood, I get a little bit of everything. It's white people, it's Asian people, it's black people, y'know. The good thing about my neighborhood is that everyone looks after each other. But, we get a little bit of everything, like I said before. We have police cars flying up the street. Somebody got shot right down the street from my house not too long ago, right where I normally get on the bus to go to football practice. He got shot and died. A little bit after that there was a shootout, like right behind my yard, almost in the school, in the backyard. So, it's, you know, in the center.

If you could change
one thing about
your neighborhood,
what would it be?

Stop all the violence. Have people get along more with each other / The littering / The crime / People getting more involved in the community, people getting to know each other more

The crackhead people / The trash / I wouldn't change anything / Make it cleaner, make better houses / Make it more quiet

OAKLAND

Everyone that lives by my neighborhood has to be safe / For them to stop fighting / All the shooting and all the gang banging / It's a lot of Mexicans. I would like to teach them English so they could communicate with us

I would change how we conduct ourselves in our neighborhoods and how we interact with each other. Everybody needs to come together as a unit, just like other people, or like other minorities come together. We need to come together, just period. Not just one race, not just black people, not just white people, not just Mexicans, but people all together. People period.

That everyone would get along with each other / No violence / To stop all the meanness / Cleaning the environment / For them to stop shooting people / Seeing trees grow and plants being watered

EASTMONT MALL

Its location. It's a good neighborhood, just better location. Like maybe, a little closer to the water.

I would change how we conduct ourselves in our neighborhoods and how we interact with each other in our neighborhoods. Everybody needs to come together as a unit, just like other people, or other minorities come together. We need to come together, just period. Not just one race, not just black people, not just white people, not just Mexicans, but people all together, people period.

The violence.

EDNA BREWER MIDDLE SCHOOL

The crackhead people.

The amount of dogs barking at night.

To make it more quiet.

There's really nothing to change about my neighborhood.

The trash.

How different the weather change.

Probably the location in the hills.

No smoking.

I would change the violence everywhere, because there is violence everywhere, but it's more common in certain places.

I wouldn't change anything.

Make it cleaner, make better houses.

MARTIN LUTHER KING, JR. ELEMENTARY SCHOOL

That everyone would get along with each other.

That there don't be a lotta cars parked, sitting in their cars, people be sitting in. Yeah.

Definitely the cleaning up. I would get all the trash up off the floors and make sure the streets get fixed. I would put a speed limit, like probably 30 mph or 20 mph, because some of us kids, we play baseball and stuff in the street, but people speed by. I don't want that.

No violence.

For them to stop shooting people.

To stop all the meanness in my neighborhood.

Cleaning the environment-thing.

Seeing trees grow and plants being watered.

OAKLAND TECHNICAL HIGH SCHOOL

Stop all the violence and stuff. Have people get along more with each other.

The littering.

The way the buses run and the violence. *(Q: Why would you pick those two?)*
'Cause I gotta walk kinda far to get to my house from the BART Station and the violence has been outta control lately. It's just a lot going on.

The crime.

People getting more involved in the community. People getting to know each other more and doing stuff together.

PARKER ELEMENTARY SCHOOL

What I could change about my home is to get out of Oakland. *(Q: Why?)* I want to get out of Oakland because I think it is a bad place, a bad neighborhood to be in. *(Q: What makes it bad?)* What makes it bad is all the violence stuff around here. *(Q: Has that affected you in anyway?)* Yes, it affected me in any way because, one time, I was watching a movie in my living room and I heard a gunshot right by my house. *(Q: What did you do when you heard the gunshot?)* What I did when I heard the gunshots is I turned everything off in the living room and ran to my mommy's room.

What I would change about my neighborhood... is stop the violence and stop being messy.

Everyone that lives by my neighborhood has to be safe.

For them to stop fighting.

The violence.

I would try to stop all the violence, all the shooting and all the gang banging.

If I could change one thing about my neighborhood it would be – it's a lot of Mexicans. I would like to teach them English so they could communicate with us.

Do you have
any adults you
can open up to?

FAMILY: 83.8%

OTHER: 16.2%

MOM – 20.5%

DAD – 18.1%

GRANDMA – 10%

BROTHER – 7%

COMMUNITY OF FRIENDS AND/OR FAMILY – 6%

GRANDPA – 4.8%

AUNTIE – 4.8%

UNCLE – 4.8%

STEPDAD – 4.8%

TEACHER – 3.6%

COACH/MENTOR – 3.6%

COUSIN – 2.4%

SISTER – 2.4%

GIRLFRIEND – 1.2%

STEPMOM – 1.2%

THERAPIST – 1.2%

BOSS – 1.2%

FRIEND – 1.2%

NO ONE – 1.2%

My mother. My grandmother. My grandfather. People like that. They're just people that understand me.

My aunt and my cousin. They are really the ones who I can express my feelings to and not expect a negative answer. You will always get what's right. There is nothing negative about it. Hurtful to your ear, it's still a positive message. They make sure that you get it rather than just tarnishing you.

My 8th grade English leadership teacher, Mr. Bell, Vernon Bell. In the 8th grade, when I was younger, I was bad. I did a lot of things I shouldn't of did.

Mr. Bell, at the time, he really played that father figure for me. My pops never been around. In the 8th grade I used to be the first one at school, first student. And for the longest time I used to just kick it in the library and cafeteria. And I noticed that my English teacher used to be at school before anybody.

So halfway through the year I found myself being in the classroom before school for like an hour, just chopping it up. Before school he wasn't Mr. Bell, he was Vernon and his facilitator cap was off. He was now a regular person. The way he talked was different, the way he presented himself was different. And his beliefs was different. When he showed me that different side of him, I felt that connection was much more greater than Mr. Bell, my teacher, my English leadership teacher. I felt like within that hour before school, Vernon talked to me like he actually cared and his interests were to better me for the future, rather then apply things out of the textbook that Mr. Bell was giving the class. I felt like that hour of individual attention allowed me to open up and talk about things I never got to talk about with my own dad or with anybody period. Mr. Bell, I will always have love for that man. He made a big impact on my life.

I don't want to leave out Lukas, Lukas Brekke-Miesner. He runs PAST 2 at O-High *(Oakland High School)*, and he works for Oakland Kids First. He runs REAL HARD, representing educating active leaders having a righteous dream. The moment I met Luke, I thought in my mind I'm not going to let him down. I'm not. You don't get that with anybody. Just think about it, you walk into a room and you make eye contact with another person and the first thing you think in your mind is I'm not going to let him down. That's inspiration. That's motivation. That is a role model. Luke is my big bruh. He makes it so easy to be you, to be yourself rather than try to be whatever everybody wants you to be or to follow what everybody else is doing. Lukas is really impactful.

— *Mario McGrew*

My grandmother. If not, then writing, or myself.

My mom, my dad, some of my coaches and my girlfriend at some points, when she don't get on my nerves.

I got uncles, I got a mom, I got a whole circle of people I could talk to, you feel me?

I'm actually really fortunate. I was brought up by my mom mostly, and then all of her side of the family, like her sisters, my aunts, and all of her best friends. I was really fortunate to grow up in a really strong community. There's that word again, community, right? It was good and it still is.

I have a family we call Hothead. We rap, we chill, we relax – they older than me, I'm basically one of the youngest, but they just somebody I go to when I, you know, feel down, whatever, just to chill, just to talk about anything. Anything and everything.

My mom and my stepdad. *(Q: Why?)* Because they just been really supportive and every time I tell them something, like, if I have a problem, they really try to help me solve that problem.

Parents, step parents, parent's parents, that's it, you know. *(Q: And why can you open up to them?)* Because I feel comfortable around them, unlike some of the teachers that just throw me some bullshit excuses for work.

My dad, you know, I was fortunate to have my father around and I open up to him and talk to him a lot. He has a lot of knowledge and everything.

There's my therapist. I trust him and that's kind of his job so... *(laughs)*

My boss, who's also like a very good friend of mine.

My step father. And also my mother.

My mom, my dad, and my family.

My auntie, my mom, and my grandma.

I can talk to my brother about my feelings. I can talk to my mom and my dad, and I can talk to my grandma about my feelings and my teachers.

My granny and my grandpa. *(Q: Why?)* Because those are the people that kept me going during my childhood.

"I can open up to my dad because I feel like he watches out for me all the time."

— *Carlton McWoodson*

Where do you
feel safe?

HOME – 46%

SCHOOL – 14%

ANYWHERE – 10%

OAKLAND – 8%

NOWHERE – 4%

FOREST – 2%

IN A ROOM FULL OF MUSIC – 2%

GRANDMA'S HOUSE – 2%

WITH MY PARENTS – 2%

DAD'S HOUSE – 2%

AUNTIE'S HOUSE – 2%

CHURCH – 2%

THE POLICE STATION – 2%

IN MY HEART – 2%

HOME

I feel safe at home 'cause everywhere you go it's the danger zone. You step foot anywhere, wrong place, wrong time, you never know.

Well, I feel safe in the hallway in my house. *(Q: And why do you feel safe in the hallway at your house?)* Because it's dangerous outside and in my room because they shoot. And one time I heard one, like it was flying by the window, because they were shooting from very far back at somebody else that was very far back, so they have to shoot up and I live in a building that's high. That's why I feel safe in the hallway.

I feel safe at my house, except when people are sitting outside in their cars, *(Q: And why do you not feel safe at that time?)* Because either I feel like they're gonna do something and I feel insecure.

I feel safe at ... home because I know that when my dad's around I can feel safe and I can do whatever and then hope that I can, and know that I won't get hurt.

My home, because nobody breaks in it at night.

At home. Because I feel safe there because it's only me and my mom and my baby sister and my mom's friend and we always stick together. And if we stick together, I feel safe there, so everybody in the house they feel safe and so do I.

Home. Because I can lock my door... and I got my pit bull to protect me. Mm-hmm. (nods his head)

SCHOOL

I feel safe at school. Because although there is a lot of competition and jealously, school is a place to go to feel safe. I know a lot of people who come to school with the thought in their mind, I'm going to see so and so up there. I hope she doesn't come over there with that rachetness. School to me is safe. There is nothing gonna happen to me at school. Because if there is something that happens to me at school, somebody is going to get into trouble and it's not going to be me. So if you can't be safe at school, than that tells you about society. You don't go to school to feel violated, to feel in danger.

I feel safe at school and at home. At school because I know nothing's gonna hurt me and 'cause I know I have a good principal and I have great teachers and great people that can help me.

School. (Q: At school?) Yeah, 'cause of the teachers.

Here. (Q: In school?) Yes. (Q: And why do you feel safe here?) Because I am learning and we have a security guard guarding us and we feel safe here.

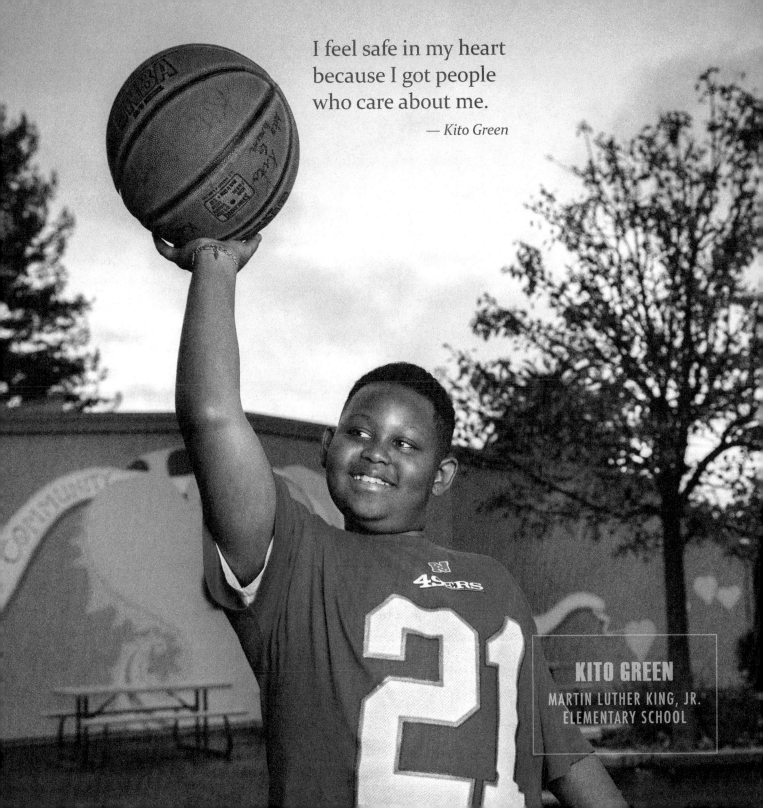

I feel safe in my heart because I got people who care about me.

— *Kito Green*

KITO GREEN
MARTIN LUTHER KING, JR.
ELEMENTARY SCHOOL

ANYWHERE

Pretty much anywhere. I'm not constantly looking for reasons to feel unsafe.

Anywhere. Why? Because I don't go anywhere looking for trouble and trouble don't come around here looking for me, so I can walk around anywhere.

NOWHERE

I never feel safe. We do live in Oakland. Last time I checked it's not a safe place to be, so I never feel safe.

I don't feel safe nowhere out here. I don't feel – you could die anywhere out here. I don't feel safe nowhere. People get killed down here, people get killed – my neighbors across the street, on their porch, got killed one night. I don't feel safe in the house or out the house. I don't feel safe for my granny. She works in West Oakland, 12:00 pm to 1:00 am. It's killings over there. I don't feel safe out here. It's just – you won't feel safe until you outta here, basically.

OAKLAND

I feel safe in the city, you know, around a bunch of people. (Q: Why?) Because I feel like everybody is looking out for each other and I can really express myself when I'm with people.

Well, I feel safe in Oakland because this is where I grew up. I was born and raised and I feel safe all throughout Oakland. And I just think it's because I grew up here. Couple of my friends got shot and a couple of fights have broke out, but I've never been one to fear anywhere that I went. It was kinda like, if it happened, it happened. If I'm there and it's the wrong time, it's the wrong time. But I feel like God got me anywhere I go, so I don't really worry too much about that.

IN THE FOREST

In the middle of nowhere, in the forest. In the redwoods, way up north on the Lost Coast. That's where my heart is. That's where I feel safe.

IN A ROOM FULL OF MUSIC

GRANDMA'S HOUSE

WITH MY PARENTS

DAD'S HOUSE

I feel safe by my dad's house. *(Q: Why?)* Because when I was here, it's too dangerous where I live over there, because people shoot too much. And when I am at my dad's house there's never no murders or anything and I feel safe.

AUNTIE'S HOUSE

CHURCH

THE POLICE STATION

Oh yeah. The police station. *(Q: Why the police station?)* 'Cause, if somebody try to come take me, the police will arrest them.

What do you love
about Oakland?

I love our diversity. If you look around Oakland, you see we have a little bit of everyone out here. We have Indians, we have black people, we have every type of Latino out there. It's like everybody out there. That's what I love, our diversity.

I love the scenery and history of it, because it's gorgeous besides the violence and whatnot.

It's Oakland, come on. **It's the city of everything.** You could find the biggest buildings, the smallest buildings. The best looking female, the worst looking female. It teaches you character. It teaches you how to be smart, how to be tough. It has two environments. It's Oakland. It's the heart of California.

There is no place like Oakland. Regardless of all the dangers you have to put up with, regardless of all the hatred and jealously and insecurities that people walk around with, Oakland is beautiful. There is no place like Oakland. I can't say that enough. Diversity is one thing. I never been to a place that has so many different cultures, different sizes and shapes, voices, frequencies and smells. Everything is diverse. No matter where you turn, it's going to be different. And I feel like it's a great learning experience, because if you around something that is similar and you around it for a long time, when you get put into a situation that is different, you don't know how to cope. I love the fact that Oakland is so diverse and when you look past the danger, you look past everything that makes Oakland, it's a livable place. **A lot of great people are being built in Oakland.** I feel like Oakland doesn't get enough credit.

The first thing I love about Oakland is how **there is more outreach for the youth.**

I love the diversity about Oakland. Like there's hella different people in Oakland and they're all from different backgrounds, and they're all like hella cool. And for the most part, everyone kinda gets along. So, its cool.

I love everything! From the buildings, to the lake, to everybody. Everybody's hella different out here. I like the way people think out here, I like every culture out here, from Caucasian to the blacks. I like scrapers as well as Benz. I like everything out here. We got a culture of our own. There's everywhere, then there's Oakland.

I love the diversity, you know, no two people are the same. I'm from North Carolina, and a lot of the people, you know, it's real cookie cutter. But **here, everybody is different.**

What I love about Oakland is **the people, how passionate the people are.**

What I love about Oakland is **freedom of speech** and I got it here. I can go say, "Fuck the police." No I can't, I'm just playing.

Their basketball team.

Our pride and things like that.

"The one thing I love about Oakland is that we struggle, 'cause everyone needs to struggle sometime. They say you never actually get up until you fell down. Oakland, we fall down. Only way from here is up, so that's as far as I see it."

— *David Hokes, Jr.*

What I love about Oakland is **the community.**

I don't really like Oakland. *(Q: Aw, why don't you like Oakland?)* Uh, it's too much shootings and stuff.

I love the fact that **I can feel safe all through the city**, with or without people guiding me through.

I love that **there is nothing like Oakland.** The Bay Area is the bomb. And the Golden State Warriors and the Oakland Raiders.

I **like the sights we have**, like we have Lake Merritt and then there's Oakland Hills and you can see all across the bay – and it's really cool to look at.

That everybody's usually nice. Not nice to each other, but **everybody's kind of welcoming** people into their circle, kind of.

It's creative, and that's where I live

I love that **there's really good people in Oakland.**

That **the community cares**. They'll have a meeting sometimes, and they'll get somebody to be a watch, and watch what is going on so they can call the police and tell them that there's an argument going on, "Could you please come help?"

That it got swimming pools.

I like Oakland **because it's fun.**

My favorite baseball team made it to the playoffs.

It's a lotta African Americans.

You can become something out here.

How everybody, like, hold it down.

The city has a lot of potential.

I don't love anything about Oakland. *(Q: You don't, why is that?)* I don't love anything about Oakland because of all the bad stuff that be happening.

They have a good beach.

I love the people. And there are a lot of people in Oakland who encourage me to do better.

We got events going on. We got kids going to the afterschool programs. We got kids picking up where they left off and doing things positive.

Opportunity is what I love about Oakland.

Its individuality.

I love the cars of Oakland and I just love the energy of Oakland.

What would make
Oakland better?

"People stop shootin'."

— *Damien Sims*

I don't really know what could make it better. Maybe just **stop making ourselves look bad.**

If it wasn't for the fact that it is so violent and that you don't feel safe walking out at night. I mean that's one thing I'd definitely change. If I was to take my girlfriend out for a night out on the town, we might end up getting mugged, I mean come on. It's not a romantic night if somebody gets mugged, somebody get shot, get hurt. It's not a perfect night. **I want to have a safe environment for my family. I want to have a safer environment for anybody I bring here to say yeah, I live in Oakland, it's a great place.** I can't say that about this place. I want to move out of this place, if anything. It's tough living here.

Continue on this righteous path to success that I'm on right now. It starts with you. If I can't better myself, I definitely can't better my community, so I will start with myself. And I'm just trying to build peace. Trying to build confidence. Trying to build ambition for people because that is what they lack.

If we got youth, to help youth.

Make more things to do in Oakland, like, go carts, lil' dirt bikes or something... something close.

I wish that **I didn't see a lot of people that look like they've had a pretty hard time and I wish that I could do something for them or that they felt more empowered to do something for themselves.** Maybe just make it a little cleaner. Gets a little dirty sometimes.

If our education system – if we had **more schools like Dewey...** we need better teacher/ student communication 'cause Dewey, they really help you out.

If people would stop being so angry.

Man, if **we all just come together.** Find a way to help us all succeed, not tear each other down.

If **everybody was nice** and there was no violence.

That the **police would be in the non-safe places.**

No shootings. **No violence.**

If my family lived around me. *(Q: So they don't live around you?)* *(shakes head no.)* Not uh, not everybody.

Be nice to each other.

Fix up the streets and a lotta people have homes.

What I could do to make it better is – to **stop all the violence.** *(Q: And how would you do that?)* I would do that by having a group of protesters saying, "Stop all the violence."

If **they stop fighting.**

"More support for the younger generation from the older generation. Not teaching 'em how to sell dope, but teaching 'em how to do something else besides sell dope and shoot dice, whatever comes along with the hood life."

— *DeAndre Johnson*

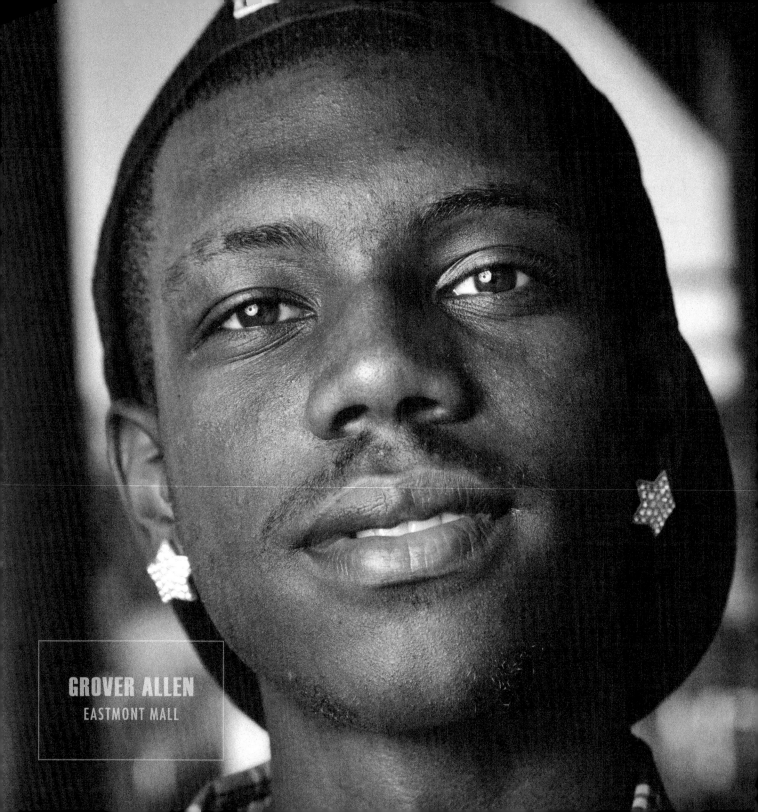

GROVER ALLEN
EASTMONT MALL

CHAPTER FIVE

WISDOM

QUESTIONS AND ANSWERS

WHAT MAKES A MAN?

WHAT HAVE YOU LEARNED FROM YOUR FATHER?

WHAT GIVES YOU HOPE?

WHAT ADVICE WOULD YOU GIVE OTHER AFRICAN AMERICAN YOUTH?

What makes a man?

What makes a man is his actions. If you have a kid and don't [take] care of it, you're not a man – you're a boy. You hit a woman – you're a boy. Do any of the things I named – you're a boy. If you actually want to change, then you're a man. It's not about how much money you make, you could be a kid at heart. I'm still kinda a kid at heart. I love video games and stuff like that. I still own my mistakes. I still try to fend for my own. Still work for what I got. That's a characteristic of a man. I don't mean to toot my own horn, just saying.

You are not a man unless you can provide for yourself fully. If you can't feed yourself or you can't put clothes on your back. If you can't get somewhere when you need to get there, you aren't a man. If you can't take care of your responsibilities and if you can't take care of your children. And if you don't have family values, you aren't a man, you aren't ready for life.

Being yourself and having something to stand up for.

I think the number one thing that would make a man a man is the **ability to not worry about if you are a man.** I think if you can just do what you need to do with your life, figure out your purpose, and find your place in the world and do good and not worry if you are a man, then I think, I guess you're a man. But, otherwise, I'd worry about being a human first.

What makes me a man is that I **don't give up.**

A man that **handles his business**. When you handle your business nobody can say nothing to you. That's when you a man.

Sacrifice makes a man a man. Learning when to sacrifice, learning when to do stuff when you need to do it. Just having a lot of discipline, I believe.

Being strong and tough.

A man has **values**, has goals, is very courageous and is smart.

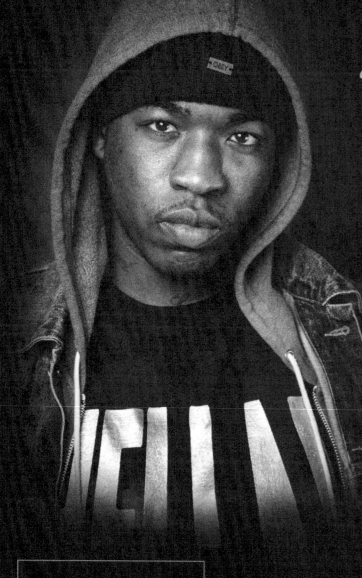

KEVIN MUNSON
YOUTH UPRISING

"**Providing.** That's what I see it as. Being able to be a leader. Someone who can make something out of nothing at all. That's what I work toward every day. And someone who is a role model. You know, a lotta people sag. I sag from time to time. Through my process of becoming a man, I have my days where I wear my pants on my behind, you know, and I'm getting to the point where it's like, every day I need to wear my pants on my behind, but I'mma gonna take the time that I feel that I need to take. I don't really like when older people say, 'Pull your pants up.' I'm gonna pull 'em up. Let me take my time, let me grow into it. Yeah. That's being a man to me."

— *Kevin Munson*

To grow up in the right place and **learn about my culture** and my past.

Being good. Not going down the wrong path, or not following in the steps that your parents took if your parents are bad or in-and-out of jail.

What makes a man is that he **stands up for his situation and responsibility. And he makes the right decisions.**

Someone who's **responsible** and who takes responsibility for their actions and is always on time and has good punctuality.

Somebody that **can take care of theirself.**

Education. And gets to grow up and go to college.

He **protects his family,** he protects himself, and he does what he gotta do.

Intelligent.

Not being scared.

To be smart.

To help someone in need. Like if somebody falls down, push them back up. And take blame for it if you did something wrong.

A graduate. *(Q: A graduate? Like, from college and from high school?)* Yeah.

Becoming what you want to be and not listening or following everybody else.

What makes a man is he has to be, like my dad always said to me, "**Your head supposed to be up and be a strong African American man.** Don't ever put your head down and be strong."

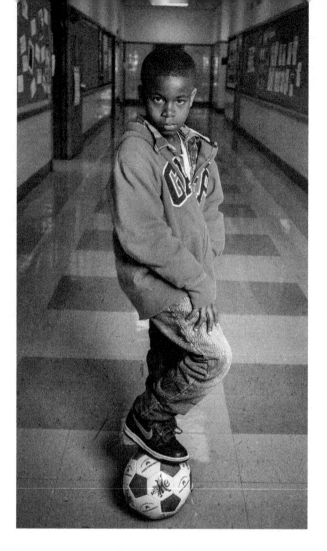

"The **muscles**. The emotion and the way that they act. *(Q: When you say the way that they act, what is a man supposed to act like?)* Responsible. Good, not bad. Act good like how you be in school, so you won't go to jail. And that's it."

— *Alonzo Holmes*

Somebody who **puts in work** to make an education and gets a job, and not just slouch. They do what they are supposed to do.

It's a man that **stands up and takes care** of his responsibilities and his actions.

What makes a man is **to know a man**, y'know. I learned that from my mentor too. You can't be a man without knowing one.

Maturity. Making sure that he knows what his priorities is and he take care of his priorities.

Handling his business, **owning up to his wrongdoing**.

What have you
learned from
your father?

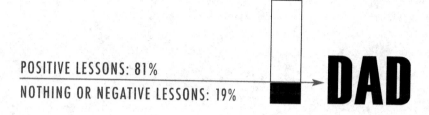

NEGATIVE

I learned not to be like my father.

To never use anything to cope with pain. Never use anything to cope with pain. Never use alcohol, never use drugs to cope with pain. Talk through it. To own up for anything wrong. He left me when I was six-years-old. He left us for about nine months with my mom and he actually came back. He owned up to that later on. It's still hard to trust him. And definitely not to use your anger to cause harm to people you love. He's doing that even to this day. Using anger to strike fear. To say, oh yeah, I'm the man of the house. But it doesn't get you far if you getting at someone you love. It makes them fear you. It makes them not [want] to be near you. It's not good, but definitely not to use anger. It's not okay.

That's deep. My father. Let's see. How not to treat my kids. How I won't be. Don't get me wrong, I love my dad. But I will not do the things he done to me or my sisters to my child. Wouldn't happen. My child will never go hungry, will never be on the street, will never do the crazy stuff he put me through. Specifically, to another African American son, his son. I would never allow that to happen.

I don't really know my father. I've had very limited meetings with him. He lived in Kenya and he passed away three years ago. I didn't really know him too well. He was a jokester I guess; my mom says I got some of my antics from him. *(laughs)*

Nothing much.

Nothing at all.

I learned from my dad – I forget.

Nothing. I mean he's deceased now, so I taught myself how to be a man.

POSITIVE

I learn to never give up. I learn if you have your mind set on something, there is nothing that is stopping you from achieving it. Pops told me, if you have children, they are your number one priority. Don't ever create something that you are just going to leave and let linger, wither up. He didn't really tell me, but he show me this. He show me that men can play that single parent role for many children and problems don't always have to occur. Pops made me somebody I couldn't be without him. Pops play his role. He taught me about everything. He taught me to respect myself, as well as others. He taught me there is no such thing as a friend. That friends aren't going to be there when you really need them to be and sure enough, he was right. He's never been wrong about that. Never. Everything I have picked up, I picked up from pops.

How to work on houses – I know how to do a little bit of remodel on houses and stuff.

I learned to stay out of stuff that's not my business.

To always be honest and to always speak my truth.

> "Have respect, loyalty, and never to dishonor."

Shout-out Pops, *(pointing to his tattoo)*, tatted. I learned a lot from him, just to be myself, just to keep going, just to be dedicated, just to stay, you know, humble. Not let anybody get to you. Eat my Wheaties – we're small, we're both short. And do my push-ups.

I learned how to provide for my family, but I also learned how to own up to my mistakes and think about things before I do it.

Shit, I learned a lot from my dad. One of the things is how to read. If it weren't for him I don't know who I would be.

How to conduct myself. How to, you know, everything. I learned everything from my dad. And that's just how I'm talking right now, how I carry myself, and what I do in school. Everything.

I mostly went to church with him, so I've learned a few things. I've learned that if you're not close to your father for a long time, then when you're older, it's kind of more difficult to be together. And he's also a teacher so he's always kind of inside my school life, trying to figure out what projects and stuff I have, all the time, and just kind of learn that he cares, you know – he loves me.

I've learned that if you step up to your challenges, you will beat them if you take the right steps to do so.

To be a man and don't let my family down, and don't let myself down.

I've learned from my father to always believe and always trust in who I want to trust in.

Money.

He's the one that taught me how to do back flips.

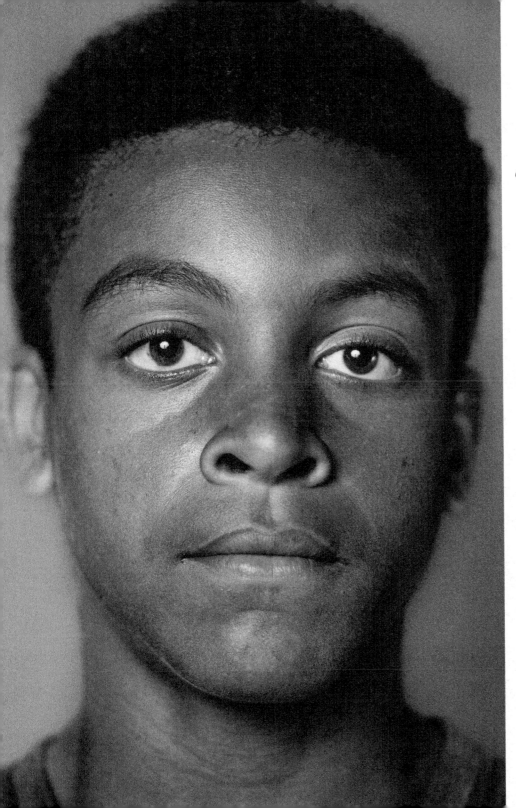

"I've learned the aspects of how to be a man, and what you need to do when you are a man. One of the quotes he told me was, 'A man who stands for nothing can fall for anything.' That's the thing that I stand by."

—*Kahlil Chatmon*

"To get an education and go to college."

— *Anthony Buffin*

Lots of tricks from my dad. Like folding paper airplanes.

Never to give up and keep on pushing. And to always try your best.

That he likes to ride motorcycles and drive cars.

How to do good in school.

What I learned from my father is no matter what, I am a strong black African American young boy.

What I have learned from my father is that he'll always tell me things. 'Cause one time, he went in jail, so he'll always tell me don't go to jail, 'cause if you do, it is like you're at the bottom of the ground. So try to don't do the same thing, like as I do. Don't go in there. But he is out now, so it is okay. He was telling me, don't get in the same situation and go down the wrong path and the wrong road like I did.

His history of being a Black Panther.

I have learned that he was a greater man and he takes no [in]tolerance from nobody.

Take care of his kids.

Be me. Be me, not worry about what everybody else got going on, mind my business. I think I put that into making music. The music that I make, I feel like that's me 100%. I've made it my own and I don't listen to anybody else. That way I stay creative in my own craft.

I learned how to build cars. I learned how to do hands-on things, like construction, or anything to do with auto mechanics, I know how to do it.

Shoot, how to be a man, and handle my business when it's needed.

What gives
you hope?

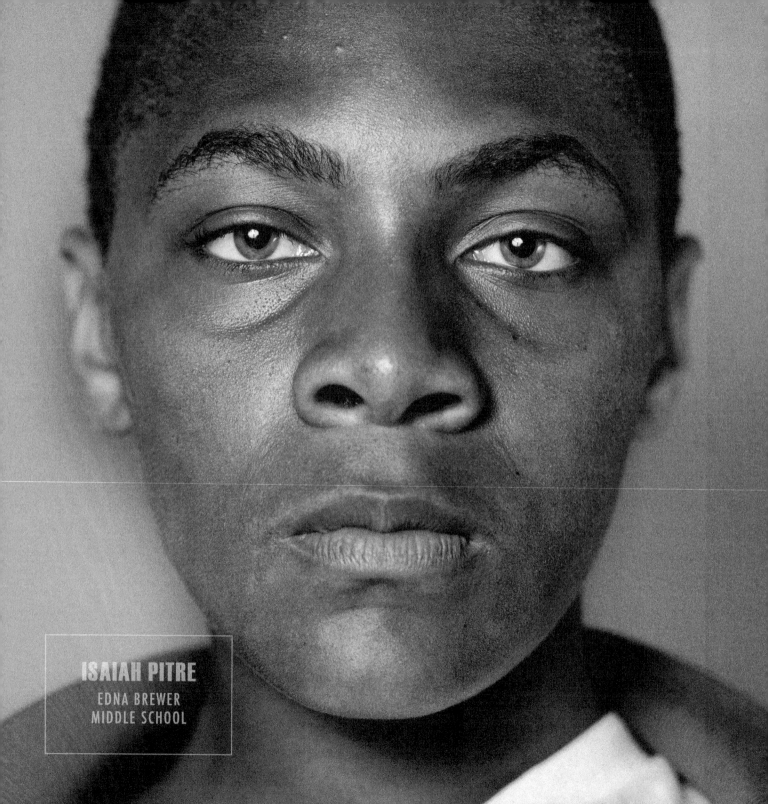

ISAIAH PITRE
EDNA BREWER
MIDDLE SCHOOL

"Jesus *(Q: Same here – and why do you say Jesus?)*
Because, my definition of Jesus is a couple things:
Hope, inner beauty, truth, power and love. All
those things just come together and they give
me, you know, one day I'mma gonna be up there
with God and Jesus and as long as I know He's
there, I'm probably gonna get up there."

— *Isaiah Pitre*

"I would say my mom, my grandmother, you know. *(Q: That family bond?)* That bond. That, you know, that we can strive. That we *can*. That's what gives me hope. And to see the young kids smile."

— *Kaulana Caldwell*

Generations. Looking at the generations coming up. Looking at my generations. We not all the same, like the last generation. My mother's generation. We not doing the same thing they were doing. A lot of us tend to have common sense, and think things out more, so it kinda gives me hope. I know we're not going to have another era of just mental retardation. Pretty much people not thinking things through.

Change. Depending on the change itself, **change gives us hope.** Me personally, I went from being a felon to wanting to have bigger dreams than that. Wanting to change my whole life around. All from having a 0.0 my freshman year to having a 4.12 at this school. Change inspires me the most. That is one thing nobody can take away from you. You can be yourself. You can change at any time. Going from being a felon to having two kids to being a multi-millionaire by changing your life for good. That's hats off. I bow to someone like that.

Family. Actually my little sister. My big sister too. They give me hope. *(Q: Why?)* Because they inspire me. They give me a mindset to do great, you know? They do some amazing things and lets me see that the next generation has the possibility to come out of the poverty.

That **Oakland can be something** that everybody says it can't.

What gives me hope? **The youth.** Children.

What others have or don't have.

Just waking up – it gives me hope. Every day is a new day. You gotta start out fresh, gotta start out new.

Seeing people graduate, doing something with they life, you know what I'm sayin'? That give me hope.

Every day, seeing more and more interracial couples, multi-racial babies. Seeing people relax. What's important is that you're kind to one another, you're not worried about silly things, you're worried about big ideas. Like, if the planet ends, where you gonna go? You gonna pollute so much you can't live someplace? You got a condo on Mars? Because if you don't... *(laughs)* yeah. People growing up and getting over themselves, I like to see that, and I see it a lot. I see a lot of people just getting to be who they are, see a lot of people walking around in drag, you see frickin' interracial couples and people just letting 'em be. It's perfect.

A lot of things.

Our generation gives me hope. I feel like we're a generation of very bright and intelligent young people. And I think that, with the right training and the right direction, we can do a lot.

My granny. I been staying with my granny these last couple of years and she's the motivation. Like her smile, you know, when I go across that stage and she is just smiling, that's just the best feeling.

The youth of our community, I feel like we can bring it up.

"Thinking about my family."

— Markai Penn

The fact that being broke, you can get rich. Being rich, you can get broke. When you live, you can die. When you die, you can't come back to life, so live it up while you've got a life to live.

Man, **not too much.** *(Q: Man, why you say that?)* I say that because I don't see any improvement happening out here. I don't see anybody trying to be super productive and trying to change Oakland. I see a lotta negative, and hear a lotta negative. Nobody's doing anything positive, or nobody pushing the positive movement out here too much.

Dreams and goals that I set for myself to become successful. I just keep moving off of that. Yeah.

My mom and my family.

My family.

To wake up every day and know that it's a good day.

It gives me hope **to see little kids doing the right thing**, helping each other out – even if they don't like each other, I'll see them volunteering and being good.

My family. Teachers sometimes, my friends and **my positive thoughts.**

(Shakes head no) (Q: Nothing gives you hope?) (shakes head no)

My mom and my dad keep me safe and my sisters.

Definitely **my best friend,** James. *(Q: Your best friend James?)* My best friend James. *(Q: How does he give you hope?)* He gives me hope because he inspires me to do things. He works with me 24/7. We go outside, practice basketball, football. And then sometimes my cousins, they come over and we just start working, doing our school work, and then after my mom says I'm done, we go outside. We study for a little bit before we go outside, then we go outside, play basketball, football, and it just be a lotta fun. *(Q: Okay, does he inspire you to do better in school and in sports?)* Uh-huh. He tells me to eat healthy. That way I can be fast like him. He's super fast.

Jesus.

My family.

I really don't know.

Dreams. *(Q: What type of dreams?)* To be in the NBA.

The fact that I can actually do something great. And that I could be actually a positive, successful African American male, out of Oakland, and that I could do it.

To follow in my dad's footsteps. *(Q: And what is that?)* To be a racecar driver.

To believe in something. Something that gives me hope is **a nice, fine, caring community.**

My education.

"Football."
— *Antoine Chatman III*

> "My mom's words saying that she is proud of me becoming the African American I am today. *(Q: So that keeps you motivated?)* Yes."
>
> — *Christian Taylor*

Everything. *(Q: Can you explain?)* Everything. **I get hope by my mom** because she just bought us a new house with all her effort and her money. So I really thank her by making a good new house. She gave me things for being good in school. So I try to do my best in school and try to get my education.

My friends and the people I like being around most of the time in school. **Sports.**

People around me and my family.

Me. Y'know, self-motivation is better than anything, so that's my hope.

Support. *(Q: From who?)* Family. Family, meaning those who are loyal to you.

Being able to wake up every morning. Living. Being able to know that I do have family. I don't have much, but if I ever need anything, my mom and my brother is what I have, and that's enough for me, you know. I got a father-figure. I don't know my biological father, but I had somebody there that I was able to call dad and I think my family is what pushes me and gives me hope.

Waking up every day. That's what gives me hope, waking up every day, and going home at the end of the day.

What advice would you give other African American youth?

I would probably tell them to **be themselves, stay in school, don't do drugs,** things like that.

Never quit. There's a saying in my house, "You miss 100% of the shots you never take." If you're a drug dealer right now, just don't. You could do so much better with your life. If your goal is drug dealing, guess what you could also be good at – business. Like seriously, you're pretty much your own business. If you convince somebody to buy drugs, don't let them buy drugs. You're pretty much ruining families, ruining relationships over drugs just to make some money. You could make 10 times that if you graduate college.

Like seriously, as a banking investor you know what you're doing. Coming out of college you're getting almost a million dollars a year, after four years of learning. And what are you making now? Around $600 a month on drugs? Come on man, you're going to jail for that? Dude, you could afford your own fancy mansion, your own Rolls-Royce. You could afford anything you want. And you could afford how many baby mommas that you have to pay child support? That's so aggravating to me. You guys could do so much better. I know people like that. They're so smart and talented and they don't do anything with it. They just sell drugs. They want to go out and be a ganglord and want to get shot at for money? No thank you.

"To not feel ashamed that you're African American and just be yourself."
— *Bryan Reed*

Leave Oakland. **Get out of Oakland**. That is the number one thing: [Get] my young black brothers out of here. There is a bigger world than California. There is a bigger world than the United States. Get out of here and learn new cultures. See how they react, be at peace with yourself. Love yourself. Do other things than Oakland. Oakland will drive you straight to the gutter.

I tell them to step up, **step out of their box**, take opportunities you usually wouldn't take. Don't hold back because you feel like you're not going to do it right or you feel like it's not you. Anything is possible and if you set your mind to it like I'm setting my mind, my dreams, anything is possible. No matter what you go through and what gets through your way. I advise people, young men, African American men to stay strong. There is nothing you can't go through and still survive. You can do it. You can do it. The main key would be to **stay patient, stay on-task.** If you don't see a process being achieved, take your time over what you done and look at your accomplishments. Not just at what you don't have.

Believe in yourself. You have to because nobody else is gonna do it for you. Be proud that you're mixed, that you're African, that you're whatever you are. Just believe in yourself, you gotta.

Stay in school and crack is wack.

Same thing like my dad said, to **stay out of stuff that you're not involved in.**

Keep your head straight, get on the right path, and **do what you love.**

Just be patient. Whatever you go through, keep your mind clear and know that it's gonna get better, 'cause when you're at the lowest of the low, the only place you can do is go up. It's gonna get better. **Whatever you got a talent at, if you going through some things, use that talent as a outlet.** Use that talent as a time to get your emotions out, 'cause in the end it's all gonna pay off. Don't run with the crowds, just be yourself. That's what's gonna get you rich, not what you see on TV, not all that – that's out. Just be yourself, be comfortable, handle your business, stay in school of course, drink milk and say your prayers.

Just follow your dreams and don't let anybody tell you that you can't, because you can.

Stay focused, stay driven, stay going toward a goal. Forget about the money 'cause money's gonna come whichever way you go. Just do what you really wanna do and just stick to it, you know. Don't let nobody stop what you really wanna do.

Same advice Boosie gave me: **chill out. These streets ain't cool, but grades is.**

Go to school, and stay in school, and don't stop school after high school. Keep going.

Get on the right path and stop the violence.

Stay on top of your business. Set a goal and go for it. Keep doing it, keep pushing.

Never give up, always stay positive. Do what you got to do, keep your head up, stay respectful and just do you.

Finish high school. Even if you don't plan on really doing anything after, finish high school. Because if you don't, you will remember that you didn't. Everyone will remember. High school is actually very important. This is my last year and I'm really trying to finish and I'm having struggles and problems with myself, personally. So, my main thing would be to finish high school.

Go to Youth Uprising *(laughs)* and apply yourself. **Take the initiative by being the first one to try 'cause there is no limit to how high you can fly.** If you go where there's no path, and you make a trail, you are now a leader in a position to excel.

Do your hardest. **Try not to get in trouble.**

Never give up.

"Always never lie."
— *Malik Ewing*

> "Don't get angry at people that try to hurt you 'cause you can always just back off and go tell a teacher."
>
> — *Marcus Henderson*

Set goals for yourself, because if you set goals for yourself, you'll know what you wanna do when you grow up, and that'll make you work harder to be that.

Always stay on path, on the right path.

Keep your head up.

Don't look down upon yourself. *(Q: Why?)* Because, like I said, a lot of people look down upon us, so if you look down upon yourself, then you're just showing them that they're right. You hold a connection to every single other African American. So if you go down, then you're showing other people who look down upon us that they're right and then you pull all of us down. Looking down on your past, looking down upon yourself isn't really a good thing. You're not gonna be happy in life and you probably want to be happy.

Just stay in school, and even **if you're having a bad day, don't try and inflict it on others.**

That you need to **stop being in the Blood gangs** and all that stuff. You need to focus on doing your work and then don't do all that other stuff and just do what you gotta do.

Stay ahead in school – that way you can get a good job and then do whatever you want in life.

That no matter what anybody says about you, you should always be yourself, and **never be ashamed of your skin color.**

Think before you do.

To just **stay in school.**

That they should be doing good and **staying in the right place at all times.**

Don't care about what anybody else thinks. It's about what you think and not what nobody else thinks. So, just be happy and love yourself. If somebody else thinks something about you, say okay and just move on to life because it's all about *you.*

Don't act up in school.

Stay in school.

Don't be a sin to other people. Just be nice and don't let people be mean when they say you can't do nothing.

Stay good and do your homework every day.

Stay out the streets. *(Q: Why is your advice for them to stay out of the streets?)* Because a lotta African American youth are getting killed nowadays, y'know, because they either in gangs or they don't got no good parents to lead them in the right way.

Stay in school, do the best they can, and **don't give up on nothing they trying to go for.**

To stay in school, get good grades, and **don't become a street nigga out here**, and shit like that.

Think before everything they do, because everything they do has a response, it could be good or it could be bad. So make the right choice.

Just grow up and don't get caught up in the drama in the streets.

All I got to say is, **you can do this.** All this – succeeding, getting good grades, getting a job, not getting into trouble – it's all easy. Everybody has a certain will at heart. Everybody has a strong point in their heart where you can just walk away from some things. Some people need to improve on it, some people have already improved on it and they're doing pretty good. We can all do something with ourselves, you just gotta show you can do it, just show potential and let it out.

ERICK JACKSON

OAKLAND TECHNICAL
HIGH SCHOOL

"Keep your head up and everything that seems, like, hot right now is really just not. Stay in school. Just the normal, but also on top of that, when things get hard, don't give in to the pressures around you because there's more for you. Just like my father and my coaches tell me – God gives his greatest challenges to the strongest people."

— *Erick Jackson*

To **prove to people that we can do things right.**

I don't know what advice I would give to them. *(Q: What would you say to them?)* I would say **African Americans are proud of who they are.**

Live in a safe environment.

I don't know.

To never give up they dream and keep on going.

An advice I would give my friend if he was around me right now I would tell him, the last time you said that black skin wasn't a good color. I would say black African American men need to be tough, need to be strong and **black is a good color and never forget that.**

To go for what they want to do in life. If they want to play sports or do good things, help people, they can do it.

That you guys can do better. **You can't blame everybody for your mistakes**. It only takes a man and a woman to take control of their own actions.

To stay determined, stay loyal and just do you. You don't have to fake it to make it, but just be who you are and just be proud of who you is.

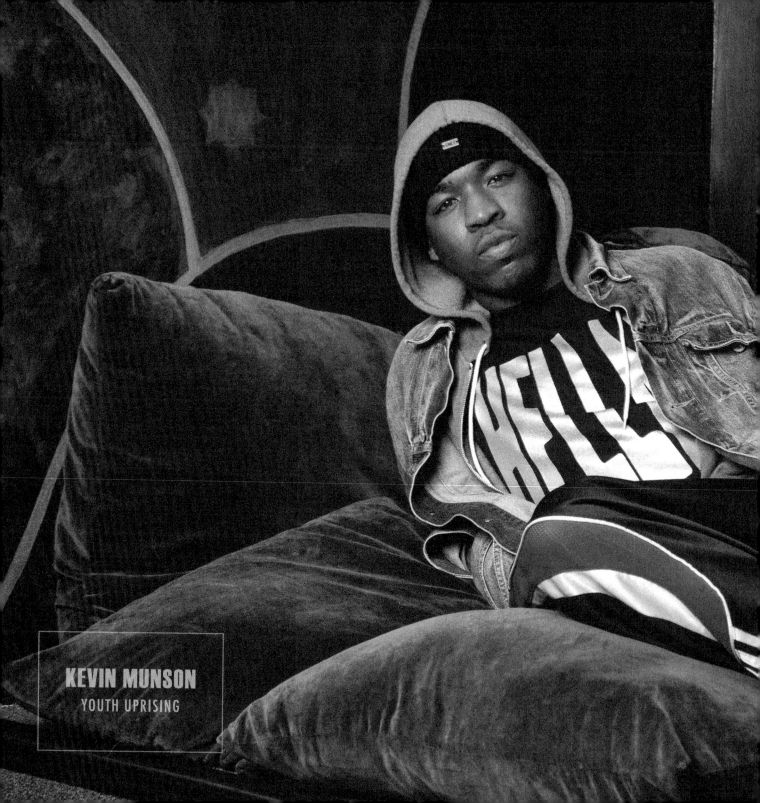

KEVIN MUNSON
YOUTH UPRISING

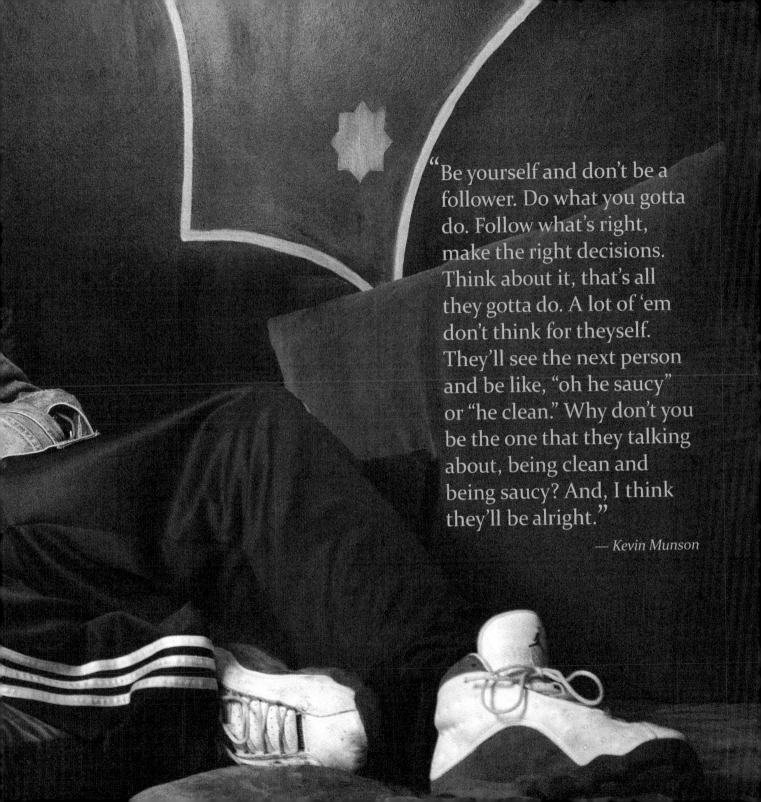

"Be yourself and don't be a follower. Do what you gotta do. Follow what's right, make the right decisions. Think about it, that's all they gotta do. A lot of 'em don't think for theyself. They'll see the next person and be like, "oh he saucy" or "he clean." Why don't you be the one that they talking about, being clean and being saucy? And, I think they'll be alright."

— *Kevin Munson*

Hop up out the streets, 'cause the hood don't love you. They'll shoot you in the backa' the head, all because they jealous of you. They want to be the top-dog, but then, they can't wait they turn, which is silly 'cause good comes to those who wait. Just be patient, you'll get you time to shine. But growing up in the hood, and living that gangsta lifestyle, or thug lifestyle, it ain't good gonna come out of it at all. I've lived it, I've done it.

I started thuggin' at 12-years-old, like, started young. I'll be 19 in a week. I been to jail three times. It took about the third time for me to have a real experience, like, I need to grow up – need to mature. It just – it just clicked.

(Q: Is there anything else that you would like to add?) It's very important to believe in yourself, because I'm pretty sure, growing up in the hood – if you watching this documentary, you know that it's not a lot of people that support you, you feel me? You may not have a lotta people that support you, or since they don't support you, you don't even support yourself. I'm telling you, you got to just be independent. Have a plan, set goals and strive to succeed. Achieve those goals.

— *DeAndre Johnson*

DEANDRE JOHNSON
YOUTH UPRISING

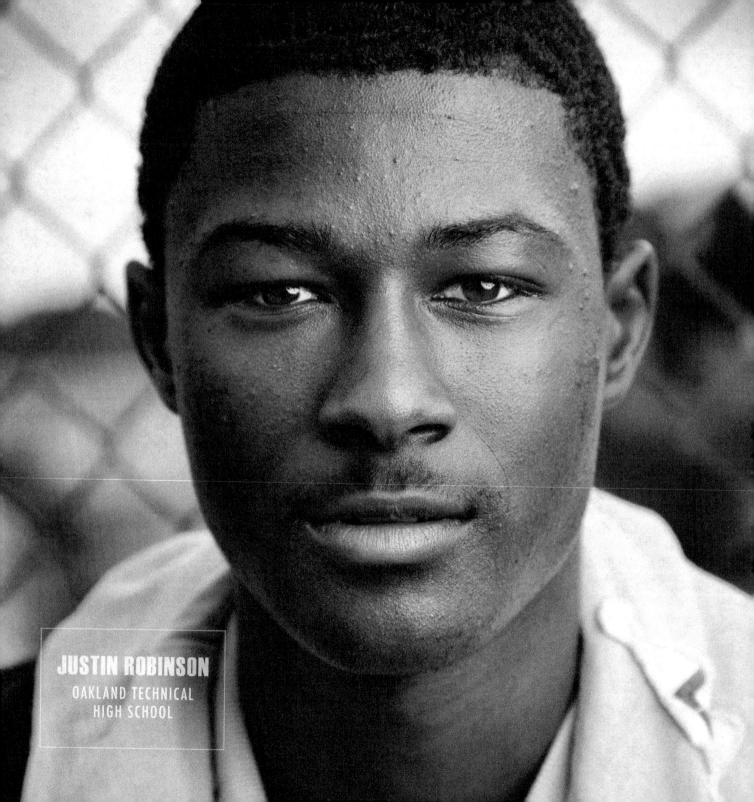

JUSTIN ROBINSON

OAKLAND TECHNICAL
HIGH SCHOOL

CHAPTER SIX

REFLECTIONS

What do you think about all you've read in this book?

This section includes reflection questions, organized by chapter, to take your contemplation deeper.

GENERAL QUESTIONS

- Please answer all the interview questions for yourself. How do your answers compare to those in the book?

- Think of a time when hearing someone's story helped you understand them better. What was the story? What understanding did it create for you?

- Which of the quotes in this book had an impact on you? Why?

- What is the general message of this book?

- Who should read this book? Why?

- What other community would benefit from a project like the African American Oral History Project?

- Is there a story about your own life that you would like to voice? What is that story, and who should hear it?

- If you could have a conversation with one of these young men, who would it be? Why? What would you want to talk about?

- Name three situations where people would benefit from coming together and sharing stories.

- Did this book surprise you? If so, how?

- How has this book contributed to your perceptions of African American men?

- If mainstream media covered stories and quotes like those in this book, how might that affect people's perceptions of African American men?

- Everyone has biases. What bias have you seen in yourself as you read this book?

- Did any of these quotes or stories remind you of yourself? Which ones?

- What is the impact of the images in this book? What stories do they tell?

- What other questions should have been asked?

- Write a three sentence summary of this book.

- How do you contribute to the stereotypes of African American men? How do you benefit from them?

- Imagine a world where prejudice did not exist, where African American men were truly seen as equal to all others. What would the world be like?

- One project is not enough to shatter perceptions of African American men. What other steps should be taken to change the discourse on how African American men are perceived?

- Given what you've read in this book, what actions will you take?

IDENTITY

- Compare the answers to the first two questions in this section. What insights does this comparison create for you?

- What are the first three words that come to mind when you think about African American men in Oakland? Now, think of an African American man you know personally. What are the first three words that come to mind when you think of him?

- What are the first three words that come to mind when you think about a Latino man? An Asian man? A Caucasian man? An Arab man? Where do these impressions come from?

- Which answer in this section was most surprising to you?

- Which of the accomplishments listed was most impressive to you? Why?

- How important is education to the interviewees?

- Looking at the answers in this section, what contributes to a person's identity?

- Three young people answered that their greatest accomplishment is being alive. What is your reaction to this answer?

- Review the list of answers given to the life descriptions in 10 years. What would you have expected to see more of? Less of?

MY LIFE

- Why were the youth asked about what they ate for breakfast?

- Review the list of answers given for the scariest thing that ever happened to them. Which of these stands out most for you? Why? Which of these can you relate to?

- How did you feel when you read about these boys being shot at or going to jail?

- Who would you guess would be the person voted most successful by these youth? Would you have guessed the number one would be their mom? Why or why not?

- What is success? How do the interviewees define success? How do their answers affect your understanding of what it means to be successful?

- Of all the school improvements suggested, which do you think would have the most impact if implemented in all schools nationwide? Why?

- Were you surprised to learn that 100% of the interviewees plan to go to college? What percentage would you have expected?

BEING AFRICAN AMERICAN

- Choosing from the answers given, what is the most important thing people need to know about African American men in Oakland? Why did you choose this answer? What would be the impact if everyone understood this?

- There are many stereotypes about how African American men look. Review the photo montage on pages 88 – 89 and discuss how these images do or do not play into these stereotypes.

- When asked what it's like to be a young African American man in Oakland, the statistics for youth under 13 years old are almost opposite to that of youth over 13 years old. What can explain this difference?

- Have you ever felt ashamed of your own culture? Why or why not? How did this make you feel about yourself?

- How do you feel when others make fun of or insult your cultural group?

- Name a time you felt proud of your culture.

- How does your culture impact your perception of yourself and others?

- Why are some cultures more looked down upon than others?

COMMUNITY

- Which of the completed sentences, "Community is..." was most compelling to you? Why?

- The red quote on page 110 came from a young boy who lives in one of the most "dangerous" areas of Oakland. What does his answer tell you about the many layers of community?

- What would you change in your own neighborhood? How does this compare to the answers in this book?

- What impact does your neighborhood have on your day-to-day life?

- Why is it important to have adults you can open up to?

- Have you experienced living somewhere that doesn't feel safe? How did that affect you and your decisions?

- Where does safety come from?

- What have you learned about the city of Oakland from this chapter?

- Do you agree with the quote on page 134 that, "Everyone needs to struggle some time?" What are the benefits of struggling?

- How is Oakland similar and different from your own place of residence?

- Which of the suggestions for making Oakland better would you implement if you could? Why?

WISDOM

- Is there a difference between what makes a man and what makes a woman? If so, what is the difference?

- One stereotype of African American youth is that their fathers are not present in their lives. What does the statistic on page 148 tell you about this perception?

- What have you learned from your father? Which answer in the book is most similar to your own experience?

- What does this quote mean to you: "The man who stands for nothing can fall for anything."

- Do you feel hopeful when you read the answers to "What brings you hope?" Why or why not?

- Who are the inspirations in your life?

- Which piece of advice resonates for you personally?

- Which piece of advice should you take to heart? Will you?

- What makes someone wise?

ACKNOWLEDGMENTS

Many thanks to Alameda County Health Care Services Agency's Center for Healthy Schools and Communities. Special thanks to the Center for Healthy Schools and Communities' Tracey Schear, Kimi Sakashita and Hilary Crowley for their vision and support.

Thanks to Cal Humanities Community Stories grant program.

Thank you to Oakland Unified School District's Office of African American Male Achievement, and especially Chris Chatmon and Brenden Anderson, whose efforts to uplift the voices and meet the needs of African American male youth included extensive support for this project.

Thank you to Story For All for designing and implementing the oral history training, story collecting and story sharing processes, and for creating products to share the youths' voices with the larger community.

Thank you to Oakland Unified School District, Dewey Academy, KDOL and the Media Enterprise Alliance for providing classroom space and recording equipment.

Thank you to the African American Museum and Library in Oakland for elevating our content, archiving the oral histories, and making them accessible to the community.

Thank you to our partners at Edna Brewer Middle School, Oakland Technical High School, Parker Elementary School, Martin Luther King, Jr. Elementary School, Dewey Academy, and Youth Uprising for creating the space and encouraging the youth to share their stories with us.

Thank you to our project facilitators: Jesse Childs, Sean Kennedy, Brenden Anderson and Angela Zusman.

Thank you to Mi Zhou for his photography and professionalism.

Thank you to Cheryl Crawford for beautifully translating this story into graphic design.

Thank you to Jelal Huyler for transcription and project support.

Thank you to our project graduates: Jarvis Henry, Sean Johnson, Nequwan Taylor, Casey Briceno, and Eric Nobles II, and the many youth who participated in the program. We thank you for showing up, agreeing to learn, sharing your light, and helping us learn from you and your peers.

Thank you to all the griots: the many youth who shared their voices with us. You inspired us greatly, and we hope you inspire others to share their truth as well.

Your voice matters. Know that you have been heard.

ABOUT THE EDITOR

Angela Zusman is an author *(Story Bridges: A Guide to Conducting Intergenerational Oral History Projects, Left Coast Press, 2010)*, oral historian, and former columnist for the Bay Area News Group. After graduating from UC Santa Barbara, Zusman spent ten years working her way around the world, spending time in over 50 countries, interviewing everyone from religious leaders to refugees, housewives to heads of state. Along the way, she recognized the power of story to connect people, even when they don't speak the same language. She also came to see that underneath it all, we humans are very much the same.

For the last ten years, Angela has taught workshops and acted as a writing coach and editor, helping hundreds of people of all ages free their voice through writing, art and oral history. In 2011, she founded Story For All to connect people and communities through the power of storytelling.